Presented in honor of

Ashere Stanton

© DEMCO, INC.—Archive Safe

asian
women
artists

asian

edited by dinah dysart and hannah fink

women

artists

An ART AsiaPacific Book • CRAFTSMAN HOUSE

Distributed in Australia by Craftsman House,
20 Barcoo Street, Roseville East, NSW 2069
in association with G+B Arts International:
Australia, Canada, China, France, Germany, India,
Japan, Luxembourg, Malaysia, The Netherlands,
Russia, Singapore, Switzerland, United Kingdom
United States of America

ISBN 976 6410 10 0

Design concept: Hannah Fink
Designers: Stephen Smedley and Marian Kyte
Printer: Toppan

frontispiece:
YI BUL, Majestic Splendour, 1995,
fish, sequins, steel, glass, 100 x 100 x 100 cm.

3/97 700.92
B & T
29.95 A

contents

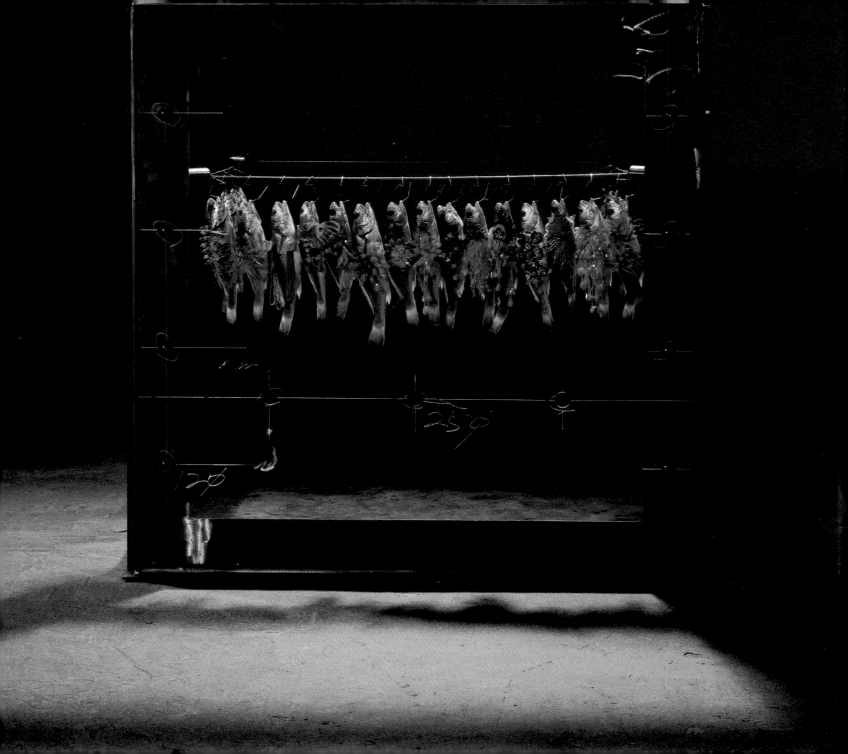

introduction

International recognition of the vitality of contemporary Asian art has been gathering momentum in recent years. The western preconception that art made in Asian countries is constrained by the need to perpetuate ancient traditions is being steadily eroded through exposure to exciting works of art by artists from all parts of the region.

Today Asian artists, many of them women, are experimenting with new materials and technology and challenging art theoreticians with innovative ideas. Others use traditional media in radically new ways or work within the given cultural language to make statements of social significance. Their work is being selected for international biennales, art fairs and exhibitions. Publications such as the quarterly art journal *ART AsiaPacific* and the increasing number of books on contemporary Asian art are contributing to growing public awareness of the creative energies ensuing from this part of the world.

At such a time, when reputations are being made and career paths are being laid down, it is important to ensure that contemporary men and women artists are given equal prominence. This collection of essays, a number of which were first published in *ART AsiaPacific*, documents and discusses art by women from a wide diversity of cultures. Many of these women are profiled for the first time in English language.

Just as Asia is a term of convenience used to embrace many vastly different countries and cultures so too are concepts such as feminism and women's art when applied to artforms and practice by women of very different nationalities and religious backgrounds. The relevance of such terminology must be individually determined. Nevertheless there are many common concerns equally applicable to a performance artist in Seoul as to a sculptor in Singapore. The writers of these essays are also of different nationalities with different perspectives to bring to the subject. These essays provide an introduction to the work of well-known and emerging women artists whose work offers many visual and intellectual rewards.

trouble at hand

... for art is very much alien to the mind of woman, and these things cannot be accomplished without a great deal of talent, which in women is usually very scarce.[1]

From Boccaccio's *De claris mulieribus*, 1355–59

jane chia

The sex of an artist matters. It conditions the way art is seen and discussed. But precisely how and why does it matter? Art history views art of the past from certain perspectives and organises it into categories and classifications based on a stratified and hierarchical system of values, which leads to a hierarchy of art forms. In this hierarchy, the so-called 'fine arts' of painting and sculpture enjoy an elevated status while other art forms such as ceramics and printing, or those which adorn people and homes, are relegated to a lesser cultural and artistic sphere under such terms as 'applied', 'decorative' or 'lesser' arts. This hierarchy is maintained by spuriously attributing to the decorative arts a lesser degree of intellectual effort or appeal and a greater concern with manual skill and utility.

The clear division of art forms into fine arts and decorative arts, or, more simply, the arts and the crafts, emerged in the Renaissance and is reflected in changes in art education from craft-based workshops to academies. In the West, by the mid-nineteenth century the complete divorce of 'high art' and craft was in marked contrast to the Middle Ages when this damaging division was not so absolute. The art and craft division can undoubtedly be read on class lines, with an economic and social system dictating new definitions of the artist as opposed to the artisan. However, there is also an important connection between this emergent hierarchy of the arts and gender – art for men and

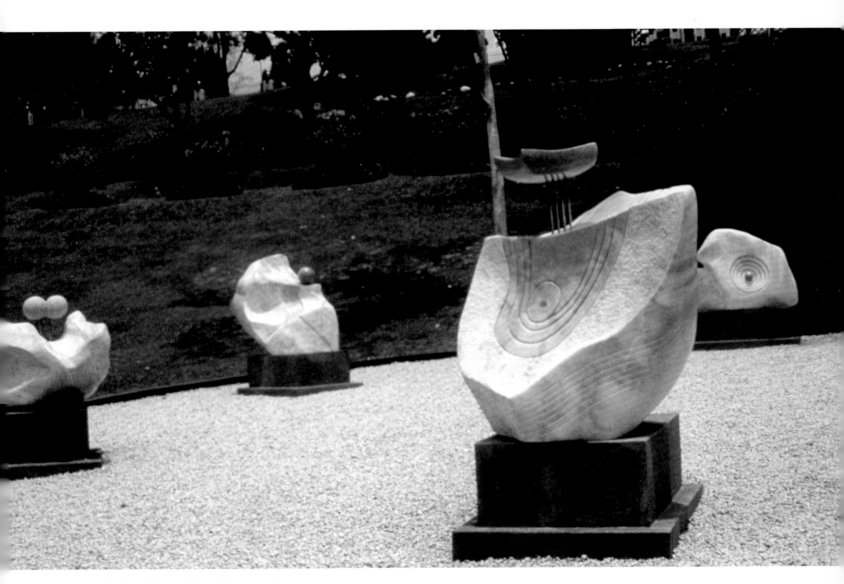

HAN SAI POR, **Towards Peace, 1987**, marble, courtesy the artist.

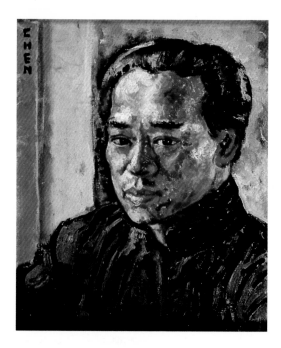

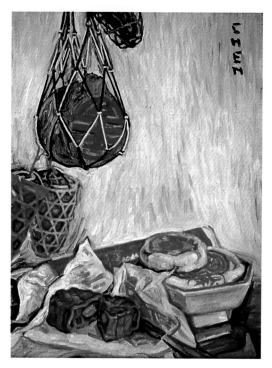

top: **GEORGETTE CHEN, Portrait of Eugene Chen, c. 1935,** oil on canvas, 41 x 33 cm, collection Singapore Art Museum, courtesy Singapore Art Museum.

above: **GEORGETTE CHEN, Mooncakes with Green Pomelo, c. 1965,** oil on canvas, 46 x 33 cm, collection Singapore Art Museum, courtesy Singapore Art Museum.

crafts for women, a division maintained erroneously on the basis of function, materials, intellectual content, class and gender. The historical process by which women came to specialise in certain art forms, such as needlework, or particular subject matter, such as flower painting, has been obscured by the tendency to identify women with specific areas of art production and imagery.

So, women who painted flowers and the paintings per se became mere reflections of each other. Fused with prevailing notions about femininity, the work was perceived as an extension of womanliness and the artist as a woman fulfilling her inherent nature. Thus, to rebel against certain art forms was to rebel against femininity, and an embodiment of both femininity and accepted female art practice. This effectively removed the paintings, the works and the artists from the field of fine arts. In addition, in most histories and critical appraisals of art women's achievements do not receive the same kind of attention as their male contemporaries. For example, there is a difference between the reputations of the two British artists Winifred Nicholson and that of her husband Ben Nicholson. Ben Nicholson has been validated as an important modern British artist, Winifred Nicholson has not. Yet, in comparing their careers, she produced a body of work arguably as distinctive and experimental as his, and in many ways more vibrant and remarkable.

Is there something about the way that women are perceived in patri-archally determined societal structures which tends to undermine and downgrade the significance of their work? Is it their male-supporting roles as wives, sisters, mistresses and artists' models, which have until relatively recently in this century assigned women to the footnotes of the art history books that have been largely written by men?

But how can women's art be known and critiqued when the works of male artists dominate gallery and collection spaces? Certainly, women artists in Singapore need to gain access to an equitable share of public exhibition space and media coverage if their work is to be made more accessible and visible.

Publications on Singapore art are rare. However, three very impor-tant and influential books on Singapore artists are worthy of close examination and analysis in terms of how women artists are portrayed. In the latest edition of the extremely informative *Singapore Artists Directory* (1993) there are 312 artist entries of which seventy-two are women, or about twenty-three per cent. Additionally, only seventeen entries represent non-Chinese artists (i.e. about five per cent) with no Indian artists of either gender and no Malay women at all represented in the directory. Similarly, in *Singapore Artists Speak* (1990) only six out of the sixty artists discussed, or given the opportunity to 'speak', are women. The book is predominantly focused on painting, with only six sculptors and one fabric artist included. And, in *Change,*

20 Singapore Artists, A Decade of Their Work (1991) there is not one woman artist represented and the selection is largely confined to painters, with only two sculptors included.

It therefore seems that the hierarchy of art forms is alive and well, a hierarchy that is determined by men who largely dominate and control art criticism and the small number of art publications in Singapore.

The three Singapore women artists who form the focus of this discussion – Georgette Chen (painter), Chng Seok Tin (printer) and Han Sai Por (sculptor) – have experimented with various techniques and media. Most artists do indeed experiment, but this quality is particularly evident in the works of these three women. The reason for grouping these artists was not to create a false homogeneity but rather to explore a range of artistic styles and traditions in which women artists in Singapore have been involved.

Georgette Chen

Georgette Chen (1907–93) is generally viewed as one of Singapore's pioneer artists. She settled in Singapore in 1954 where she taught art until her retirement in 1981. Chen was already a mature artist when she came to Singapore, having exhibited in Paris and New York. She had work selected for exhibitions in venues such as Le Salon d'Automne, Le Salon des Independents and Le Salon des Tuileries, which were considered some of the avant-garde venues of her time.

Influenced by the modern art movements of Paris (in particular post-impressionism), where she trained and developed as an artist, Chen was one of the pioneer artists who brought modernist ideas to the Singapore artistic community. Undoubtedly, too, these ideas are apparent in her own work and influenced her students through her teaching.

Her work can be organised into three quite distinct periods corresponding with her countries of residence: the French period (1927–34) China and Hong Kong (1934–48) and her work from her life in Penang and Singapore (1949–80). These three periods of Chen's artistic output are distinguishable by major changes in style and content. The early period (1927–34) is characterised by influences on her work by late nineteenth-century French artists such as Corot and Cézanne. Like Cézanne's early work, Chen was concerned with the volume and texture of objects from a very close, strategical viewpoint. Sometimes this work seems almost to be painted from above, reminiscent of some of Cézanne's early work. This period also includes Chen's work as an art student and her selection shown at the exhibition of the Salon d'Automne in 1930. Her marriage to Eugene Chen in 1930, then Chinese Foreign Minister, whom she met in Paris while an art student, involved frequent trips to China. She remained based in Paris, however, in order to continue her art studies, and her husband became a favourite

subject of her portraits until his death at the end of World War II.

During her China and Hong Kong period (1934–48), Chen's work included still-lifes, landscapes and interior genre paintings which have much in common with Fauve artists' use of colour. In the portraits of Eugene Chen of this period, Chen's style manifests many of Van Gogh's concerns and techniques. For example, the basic design of the portraits of her husband appear casual and possess the immediacy of snapshots. Chen utilises the picture plane and paints in masses of uninterrupted, sometimes slightly broken, colour. Landscapes of this time, largely executed in rough impasto, are indicative of her experimentation with materials.

From 1949 to her retirement in 1981 marks the period of Chen's maturity as an artist. She taught art during most of this period and it is on this body of work that her Singapore reputation largely rests: the figure compositions and landscapes executed in Malaysia and Singapore and the large number of still-lifes.

Unfortunately, very few of Chen's works before 1968 are signed and so precise chronology is difficult to determine and relies on her sketchbooks, country of domicile, stylistic evidence and educated guesses. However, all her signed works bear the name 'CHEN', an adaptation of her chosen *nom de plume* 'Chendana', which is clearly a reference to her married name but also a derivation of the Sanskrit word 'Chendana', meaning sandalwood. This may seem an unexpected choice for a Chinese woman painter but the name was adopted upon her establishing residence in Singapore. It seems that the name was chosen to symbolise the putting down of roots in Singapore, therefore the selection of a name of a tree native to the tropics was significant.

Primarily an oil painter, Chen emphasised developing the requisite skills throughout her long artistic career: 'I sometimes compare drawing with notes and time in music, to the grammar in language ... It is the first step in your art training ... Unlike talent, which is an inborn gift, this technique or knowledge does not come naturally but has to be learnt ...' (*Georgette Chen Retrospective 1985*, catalogue, Introduction)

Chen experimented with watercolour and pastels, although it is as an oil painter that she is largely recognised in Singapore. Chen's painting forms include portraits and landscapes, although Chen's reputation is primarily as a still-life painter. However, still-life as an art form became transformed in Chen's work once she began to live in Singapore, as it became influenced by her tropical surroundings. Alongside the more familiar still-life subjects, Chen began to paint baskets of tropical fruits and vegetables.

This transformation of a European still-life tradition into an art form which could be utilised as an effective means of communication and response to Chen's particular environment became more apparent during her 1949–81 period. Some of this work is anecdotal and

symbolic in content; for instance, the canvases depicting objects which are recognisably of culturally based significance, such as lanterns and mooncakes. Chen rejected *objets de luxe* for her still-life compositions in favour of familiar, commonplace objects in her Asian context. Other works from the same period emphasise pictorial construction and the creation of a new disposition of shapes, colours and textures.

Georgette Chen died in March 1993, after a long series of illnesses which kept her largely bedridden for the last eleven years of her life. There has yet to be public acknowledgment of her contribution to art in Singapore or a major review of her work.

Chng Seok Tin

The printmaker Chng Seok Tin was born in 1946. She trained in print-making, notably etching, in Britain, Paris and America. In 1992, she was appointed for a term as 'Distinguished Visiting Artist' in the Department of Art and Design at San Jose University, USA. Having exhibited widely abroad, on her return to Singapore in 1985 Chng Seok Tin began teaching art.

In her work, Seok Tin has grappled with the conflict between her western art training and her Asian cultural heritage. Her work manifests this deeply felt conflict in a viewpoint which moves between empathy and satire. The simultaneous juxtaposition of East and West in the work takes place seemingly without effort in her themes; for example, Chinese characters and symbols seem to blend with western techniques in relative harmony. Largely abstract in style, there are nonetheless recognisable subjects in the work of Seok Tin such as nature, and the human figure is frequently a motif.

Seok Tin has mastered intaglio printmaking, a medium little seen in Singapore and remaining unexplored. Etching is at the centre of Seok Tin's art production, as the medium allows for her versatility of line. Collage and mixed media have been added to background prints and editions of work have been abandoned for the more spontaneous monoprint techniques.

Between 1985 and 1992 Seok Tin continued to exhibit both in Singapore and abroad until a serious illness in late 1992 rendered her almost completely blind. Remarkably, Chng Seok Tin '... swung back into action ... and produced new prints ... She is also teaching again. Not content with merely sitting in the print workshop and discussing problems with her students she plunges right in and shows them how it is done'. (*Works by Chng Seok Tin*, catalogue, p. 5)

Without romanticising the achievements of Seok Tin, or underestimating her visual difficulties and her coming to terms with these as an artist, it is evident that her work has become more diverse. She is now experimenting with a wider range of materials and media, such as collage and sculpture, although she sees herself first and foremost as

a printer: 'A printer is what I am ... I can no longer see clear images on the plate, so I am using drypoint and monotype, for it is easier for me to handle.' (*Works by Chng Seok Tin*, catalogue p. 10)

Predictably, the content and subject matter of her prints have been profoundly affected by her visual difficulties. Some of her most recent, monochromatic works are emotionally charged and poignant depictions of approaching blindness. For example, in the series which includes *Reaching Out*, solitary figures seem to have thrust their way through swirling black waters which have engulfed their lower limbs and threaten drowning. The central figure is reaching out, arms at full stretch, to a small patch of pure light far above in the sky whilst storm clouds gather and, Hitchcock-like, menacing birds attack the figure's head.

The process of failing sight has to be especially traumatic for an artist. Chng Seok Tin has visually documented this process from personal experience which could well prove to be an exceptional achievement of interest to a diversity of academics. Most recently, Seok Tin has aligned herself with other artists with physical difficulties. She teaches these artists and exhibits with them, raising public awareness in Singapore of the lives of the disabled generally.

Han Sai Por

Born in 1943, Han Sai Por began her formal artistic training somewhat late in life. She trained in sculpture in Britain between 1979 and 1983, and since 1984 has exhibited widely both in Singapore and abroad. Sai Por has also had a teaching career and her first solo sculpture exhibition, 'Four Dimensions', was held in Singapore in February 1993.

This most recent exhibition demonstrated a marked departure in her work both in materials and inspiration. Previously very much influenced by natural forms and stone, 'Four Dimensions' consisted of ten related geometric installations which were constructed from fibre-glass sections painted white. These precisely executed structures, in dramatic contrast to her past work, are said by Sai Por to be an attempt at demystifying the process of art production.

In this body of work, Han Sai Por arranges and connects planes at varying angles, utilising the shadows that are created when these planes are projected three-dimensionally. Whereas in her previous sculptures the conjunction of the natural materials used and the ideas invoked struggled toward a unified expression, her 'Four Dimensions' pieces demonstrate clearly and unambiguously their material and formalistic elements. Previously, Han Sai Por carved in stone, usually marble or granite, and achieved organic-like, monolithic structures which were frequently highly polished and slightly reflective. The importance of natural materials and the influence of nature on her work and ideas have often been articulated by Sai Por: 'Stone is one of my favourite materials. In the erosion of rock by wind and water are

HAN SAI POR, **Four Dimensions, 1993,** mixed media, exhibition at the Singapore Art Museum, courtesy the artist.

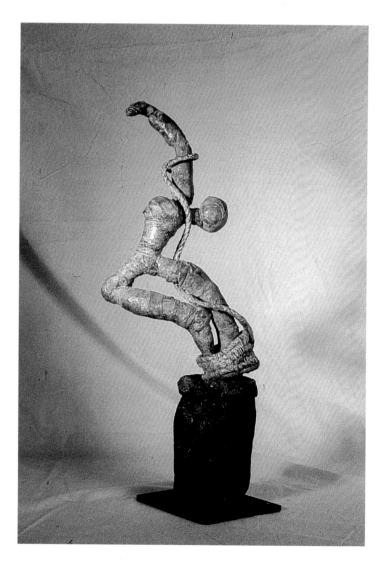

Chng Seok Tin, Free, 1992, bronze sculpture, 15 x 11.5 x 35 cm, collection the artist.

found original, vital qualities which express the significance of life.' (*Four Dimensions*, catalogue, 1993)

Two works in particular crystallise these ideals and processes, and both were the outcome of invitations to sculptural symposia. Both *Towards Peace* (six separate pieces) in Kuala Lumpur and *Childhood Dream* in Japan (six separate pieces) are carved pieces which were conceived as outdoor works. In this, Sai Por echoes the ideas of Henry Moore and his large-scale works which were designed to be sited in and part of natural surroundings, eventually transformed by the elements of nature. Han Sai Por's monumental work has also been influenced by Michelangelo's concept of the inherent, dynamic life of stone which is revealed by the sculptor. Of this body of work Sai Por has said: 'I would like to think my sculpture has a force or inner life inside struggling to get out.' (*Four Dimensions* catalogue, 1993)

Consequently, her departure into geometric and mathematical forms is surprising but indicates a willingness and need to experiment as an artist. For an artist who has long been associated with the crystalline structure of stone, this latest body of work could only have resulted from a mature artist – moreover, an artist not overly concerned with a public image but confident and committed to a personal vision, a vision which changes and develops with the artist.

Georgette Chen, Chng Seok Tin and Han Sai Por certainly share many personal and professional experiences which parallel those of western women artists. All three of these women artists trained outside Singapore and all three have lived independent lives, in conflict with the Asian cultural norms which stress family life and, in Singapore specifically, where women are subject to enormous pressures to marry and have children. All have taught art for both financial and professional reasons, being unable to support themselves as full-time artists but also wanting to directly encourage new generations of aspiring artists.

These three women artists learnt predominantly western techniques abroad (oil painting, sculpture and etching) as there were previously no opportunities for this kind of artistic training in Singapore. Frequently, they have combined these skills with Asian images or philosophy and see themselves in varying degrees as making connections between eastern and western artistic traditions. This concept has been most clearly articulated by Chng Seok Tin and manifested in her work.

All have attempted to gain recognition as artists outside Singapore with varying degrees of success. All (including Chen during her career) have exhibited outside Singapore and have maintained close links with those countries where they did their original art training.

However, women artists in Singapore remain largely unpublicised and unacknowledged. The fault lies not in female hormones or horo-

scopes but in women's access to educational opportunities – education in its broadest sense, including what happens from birth onwards as well as formalised education. Given the overwhelming odds against women and the immense cultural pressures on them towards marriage and family life in Singapore, the miracle is that some have managed to achieve so much sheer excellence in those bastions of masculine prerogative such as science, politics and art.

Ideology is not a conscious process; its effects are manifest, but it works unconsciously, reproducing the values and systems of belief of the dominant group it serves. The current ideology of male dominance in art has a history. It was adumbrated in the Renaissance, expanded in the eighteenth century, fully articulated in the nineteenth century and finally totally naturalised with the result that for much of the early twentieth century it was so completely taken for granted as part of the natural order that it was seldom mentioned. This ideology is evident not only in the way art is discussed and in the discipline of art history but in works of art themselves. It operates through images and styles in art, the ways of seeing the world and in the representation of a personal position in the world that art presents. It is inscribed in the very language of art, which has strategically and hermeneutically disempowered women.

Women artists are not outside history or culture but occupy and speak from a different position and place within it. We can now recognise that place, that position, as essential to the meanings of culture. But that position is, for women themselves, contradictory and problematic. For how do women artists see themselves and how do they produce meanings of their own in a language of art made by men, which affirms and supports male dominance and power and reproduces male supremacy through discourse?

Art is not a free, autonomous activity of a super-endowed individual but rather the total situation of art making (both in terms of the development of the art maker and in the nature and quality of the work of art itself) that occurs in a social context. That social context is mediated and determined by specific and definable social institutions and attitudes; in this instance by the art academies, systems of patronage and mythologies of the divine creator.

It is the engaged feminist intellect that can pierce through the cultural–ideological limitations of the time and its specific 'professionalism' to reveal biases and inadequacies not merely in dealing with the question of women, but in the very way of formulating the crucial questions of the discipline of art as a whole.

1 From Boccaccio's *De claris mulieribus*, 1355–59, quoted by W. Chadwick, *Women, Art and Society*, Thames and Hudson, London, 1991, p. 29.

Dr Jane Chia is Head of Art Division, National Institute of Education, Singapore.

CHNG SEOK TIN, Trouble at Hand, drypoint, 60 x 40 cm, collection the artist.

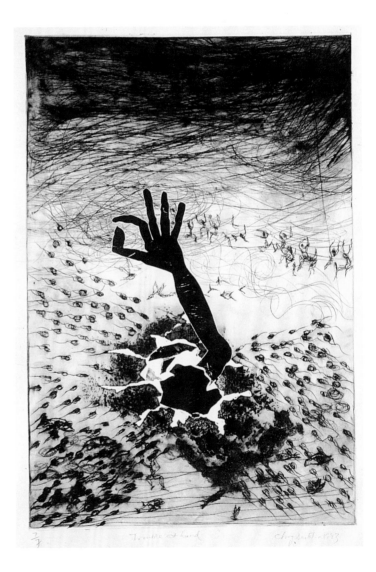

dialogue

the awakening of women's consciousness

xu hong

Women artists are recorded in the history of Chinese art, but their status is measured according to their association with men. Invariably, they are described as the wife, relation or daughter of so and so. Through extant women's literary work, notations, paintings and calligraphy it is possible to gain further insight into the creative practice of women. In the past, with the exception of embroidery, there was no art form in which there were independent female practitioners.

The first thirty years of the twentieth century was the most liberal period in recent Chinese history. Urban youth and intellectuals were inspired by western concepts such as 'equality of the sexes' and 'women's liberation'. As a result, many young women chose to dedicate themselves to art. It was during this period that a former Chinese prostitute who entered an art school in Paris went on to become one

of China's leading artists. The story of Pan Yuliang (1895–1977) is an extreme case which illustrates just what was possible at that time. Another example is Cai Weilian (1904–39), the daughter of Cai Yuanpei who advocated radical reform of the education system. Cai Weilian was educated in France and later became a celebrated artist and professor at the National Academy of Art in Hangzhou.

Pan Yuliang and Cai Weilian came from very different social backgrounds and followed individual life paths. Their spirited and optimistic oil paintings reflected their personalities and the opportunities that they were afforded during their respective lifetimes.

From the 1950s onwards there was an unprecedented increase in the number of women artists working in China. Art schools, art-related government instrumentalities and social organisations opened their

CAI JIN, Banana Plant Number 48, 1994, oil on canvas, 200 x 190 cm, courtesy the artist.

doors wide to women. Works produced by women artists reflected the major social and cultural trends of the day. Like most things, they tended to follow a standard model and female workers, peasants and soldiers were virtually the only female subjects depicted. The most important ideal was always the 'love of the Communist Party and of New China'. In the visual arts women were portrayed as robust, pure and optimistic, yet they also had to satisfy the cultural and emotional standards set for men. Women were required to be moderate and at all times appear as aides òr helpers of men. The icon which best illustrates Mao Zedong's slogan that 'Literature and art must serve the Workers Peasants and Soldiers' is the image of the 'Worker Peasant Soldier' ('*Gongnongbing*'). This leitmotif was used to create a multitude of sculptures, bas-reliefs, paintings and decorative designs. It was styled on the sculpture *Workers and Collective Farming Woman*, c. 1937, by the Soviet artist B.N. Muchina.[1] In this work there are two men – a worker and a rank and file soldier – and one peasant woman. The soldier carries a gun and stands in the foreground, the second man stands in the middle ground and points to the advancing workers, and the woman, who stands close behind, holds recently harvested grain. There was no understanding of the western concept of 'women first', that women preceded men in social situations. Rather, the dominant traditional Chinese male culture was cleverly adapted to form the basis of proletarian literary and artistic policy. The 'worker, peasant and soldier' leitmotif, therefore, can be seen to reflect and symbolise the status of women during this period.

At this time an oppositional female stereotype also emerged – the heroic woman who could brave the elements and combat nature. In contrast with the formularised images of labouring women created during the early 1950s, these women were robust, animated and bold. The portrayal of women therefore followed an increasingly masculine stereotype. This could be interpreted as a reflection of the puritanical attitudes of the ruling clique to gender issues (at least in terms of public expression). In fact this attitude differed little from that within traditional Chinese culture which ultimately equated femaleness with sexual provocation and licentiousness.

In the early 1980s Chinese art underwent profound change, the most striking aspect of which was the artists' gradual release from the control of extreme political dogma. During this period Chinese women artists once again set about re-creating their own image. This development was signalled by the shift from art which served political movements to art for arts sake. This, together with the realisation that there were different ways to depict the opposite sex, contributed to a gradual awakening of women's consciousness.

The ''85 New Wave Art' movement brought about a sudden flowering of modern Chinese art. Many young female artists enthusiastically

devoted themselves to artistic pursuits and experimented with new ways to depict society. Alongside male artists, they expressed their own attitudes towards contemporary China. Owing to the large-scale study of and borrowing from modern western art, in the initial stages of this movement women artists paid little attention to their own expression. The rebellious and questioning nature of contemporary art, however, meant that the concept of women's artistic consciousness began to emerge. For example, the artist Liu Hong painted a large number of canvases with female subjects, in which she depicted solitary, introspective and brooding young women.

The focus on the anxiety of women by women was revealed through a corresponding interest in their relationship with the natural world. This became the predominant characteristic of women's work during this period. In discussing her painting *Dialogue*, Cai Jin says, 'When I paint, my sole aim is to express that which is hidden and so difficult to express in words'. She describes this as 'the infinity that exists beyond life itself'. Owing to the existence of the infinite she is able to 'take leave of real time and space to observe the inaudible interaction between people's emotions and the natural phenomenon of the universe'. Whilst the symbolic language used by Cai Jin in *Dialogue* can also be found in paintings by men, it was by far the preferred method of expression for women. In fact, it became so pervasive that many women, unwittingly, became obsessed with self-exploration.

After 1989 individual experimentation began to emerge in Chinese art, bringing to an end the relentless collectivist symbolism of previous years. Women's consciousness began to emerge and women began to explore their own experience and find an appropriate form of expression. Most female artists sought to define the nature of women's consciousness or affirm women's consciousness itself. With respect to the former, the artistic language employed by women differed from men in that great interest was expressed in depicting objects which had a close association with the natural world. Invariably, women artists used rather tactile means to give expression to their ideas.

Shi Hui's works reflect her sensitivity to materials. She chooses to work with strips of paper and bamboo which are tied together with cotton thread to create half-spheres. Some of the forms are split, causing one to draw an association with the natural process of growth. Shi Hui's installations encourage the viewer to create his or her own meaning from the works. This is in part because of the sense of intimacy and identification that one feels with the materials and the tactile surface of the forms. The objects exude a latent energy or life force. This is due to the way in which the individual spherical units can be stacked to create a larger whole which itself seems to have the potential to be added to and reproduced. The pitted and split surfaces suggest an unending ability to absorb and procreate.

CHEN HAIYAN, **Goddesses (Dream 21 December 1986 Part 5), 1989,** woodblock print, 24 x 17 cm, courtesy the artist.

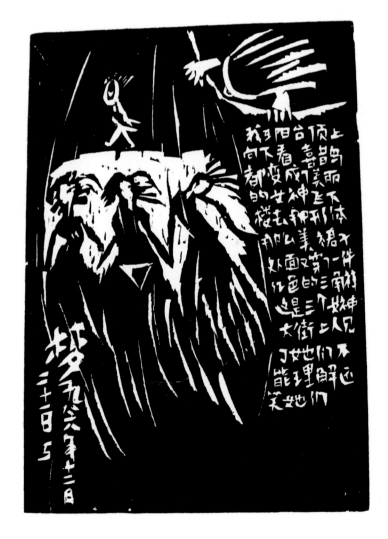

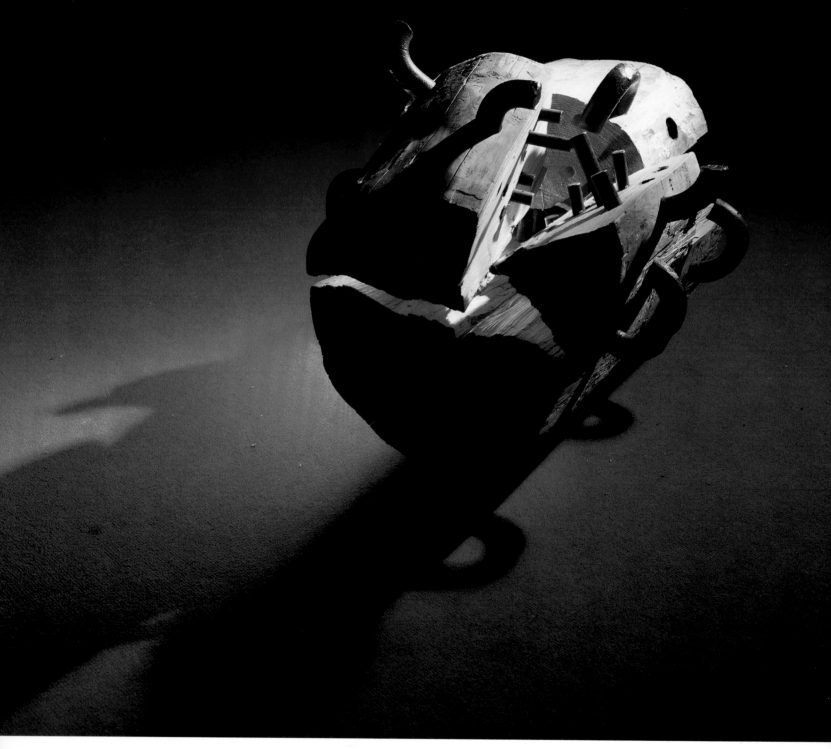

above: **LI XIUJIN, The Opened Space, 1994,** pine, iron, braille, 90 x 90 x 75 cm, courtesy the artist.

opposite page: **CHEN YANYIN, Box – 3, 1993,** wood, copper, light, 50 x 50 x 70 cm, courtesy the artist.

Li Xiujin has been practising sculpture for many years. In contrast to Shi Hui, she is interested in exploring the tactile potential of art and expanding accepted uses of materials. She has chosen the subject 'Blind person reading braille' to challenge our understanding of visual perception. The 'objectness' that she expresses differs markedly from our traditional understanding of objects as things which are incapable of imparting emotion or life spirit. Li Xiujin aims to portray the innate power of objects. In a series of marble sculptures the stone has been carved and polished to create a book form. One half has concave depressions and the other echoes this shape with convex protuberances. Both forms appear to have grown from the book. They exist to be touched rather than viewed, and in so doing they deny sensory pleasure to one group of people but give great pleasure to another. A group of blind children who 'read' Li Xiujin's books in the exhibition happily engaged in a rewarding dialogue with the artist. In another series titled 'Wood, iron and braille', the artist moves from a dialogue with knowledge to one with the natural world. By stripping the bark from a log of wood, and cleaving it open, Li reveals the rough interior 'flesh' of the tree. Into this pristine surface she has inserted some rounded iron rods, creating an image of pain, suffering and violation. There is a tension and conflict between the wooden log which is at once solid and rough yet yielding, and the metal pins which are hard, smooth and cold. In some respects the work may also be seen to give expression to the experience and innermost feelings of some women. According to Li Xiujin this work is also like braille and should be read. She feels that art should not be confined to the visual realm and that those who have been labelled 'disabled' should be able to appreciate works of art through touch and experience.

If it is said that the two above-mentioned artists represent a gradual emergence of a recognisable women's art, then there are other female artists who choose to emphasise artistic consciousness and who are determined to engage and do battle with entrenched male artistic principles. Sometimes the expression of women's character (often through materials and forms) and women's consciousness (ideology) are both manifest in an artist's work. This is because women's consciousness must be expressed through an understanding of the female character.

The art of Wang Gongyi clearly expresses her own position with regard to the deconstruction of male art. She deliberately shifts and denies the artistic language that has been handed down to her from male elders and instead chooses to make her own casual markings with countless dots and lines. She uses Chinese words in a way that defies linguistic logic. She pins small pieces of paper which have been casually painted onto a piece of *xuan* paper blackened with ink to form a free component within the painting. In this way she expresses her 'disbelief that there are really that many "rights", "wrongs", "yeses" and "noes"'

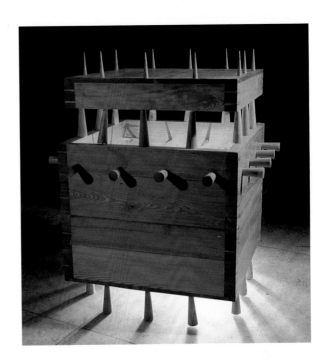

in the world. She opposes deep and philosophical interpretations of artworks, feels that the greatest things in the world are the simplest, and believes that only where magicians are concerned is there a need for complexity. She ridicules all artists who think of themselves as 'great' or 'masters' and says that she is incapable of deep and meaningful conversation. Owing to her sensitivity to visual language her works are imbued with a strong modernist rebelliousness. It is really only through her sensitivity to an unfettered form of expression that it is possible to discern any gender-based characteristics within her art.

The printmaker Chen Haiyan expresses gender issues in a more conscious manner. She uses the rich and powerful imagery of dreams to create black and white woodblock prints which expose her innermost thoughts and feelings, tinged with sadness and hurt. It may be said that the dreams symbolise the suppression of female consciousness. In a small woodcut Chen Haiyan depicts three beautiful women. Text incorporated into the image tells the viewer that the three goddesses have transformed themselves from magpies into women. They wear red G-strings over their skirts and as a result are subject to ridicule by those who walk along the street and laugh in amazement. The text suggests a resistance to sexual discrimination. By employing artistic language which emphasises gender, this work may be seen to challenge the dominant male position within society. The work takes issue with the notion of body as object – that the female body becomes an object of control and suppression. To use the body as subject to confront this notion is the most real and powerful of artistic choices. (This extreme

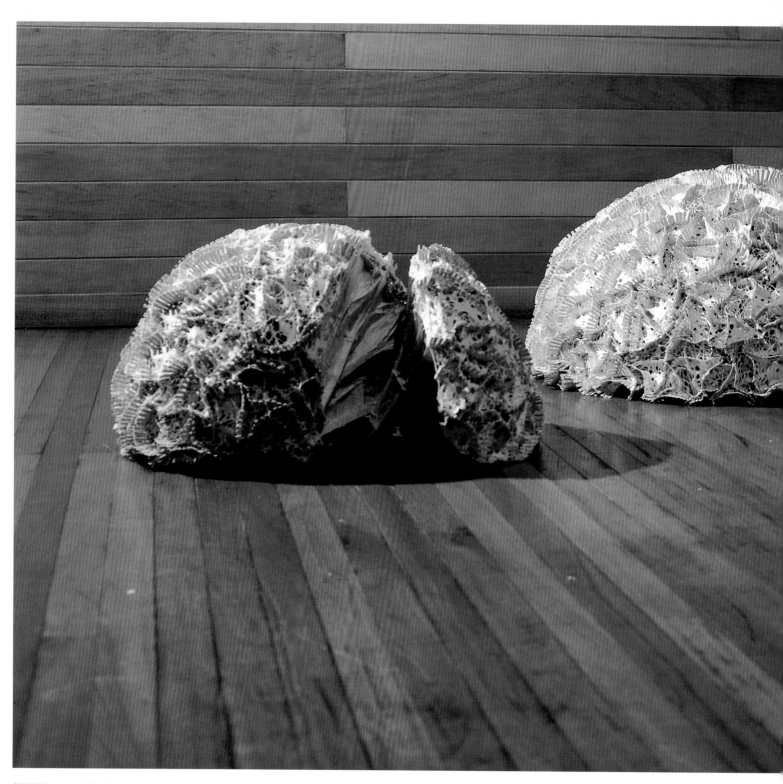

SHI HUI, Nest, 1992–94, paper pulp, bamboo strips, cotton thread on wood floor, 100 x 85 x 75 cm.

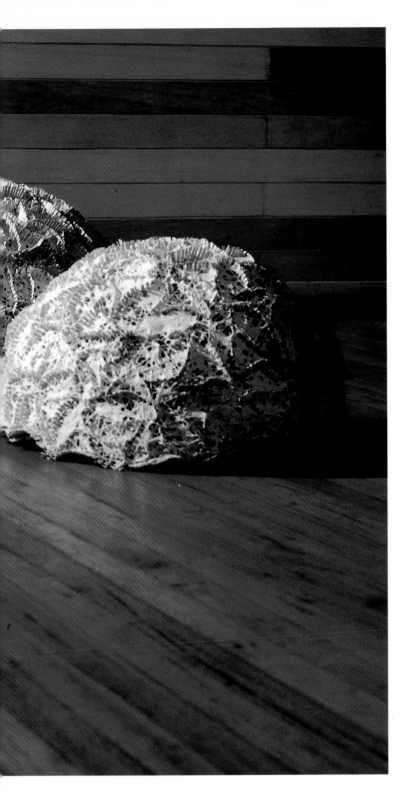

position may be compared with the woman artist Lu Qing, who used to paint in an abstract manner. In early 1994 she produced a poster with a photograph of herself and the caption 'I am a slut', causing amazement from onlookers.)

Chen Haiyan's work *Horse* reflects a different type of anxiety – that of mother and wife. It is as if the artist must overcome her anxiety in order to gain salvation: hence, her painting titled *Black Butterfly*, onto which she has written, 'I saw two black butterflies on the tree trunk making love. I broke the branch that was in my hand and then placed it back in its original position. All of a sudden it was transformed into a sacred red horn'. The black areas within the work express an emerging life and energy which give strong expression to women's consciousness.

Painter Cai Jin and sculptor Chen Yanyin both use women's consciousness as the point of departure to break through the formula of traditional art. Cai Jin uses oil to depict what look like giant cockscomb plants which seem to grow before your eyes. The paintings are imbued with an otherworldly quality. Their surface seems to be covered with meridians and ooze with blood. Chen Yanyin uses objects from everyday life such as tables, and irons – smooth surfaces onto which she adheres sharp and pointed forms. Her works bring to an end the habitual nature of daily life and force viewers to reconsider the rationality of their original thought processes. Her works are sensitive, penetrating and unusual. The careful crafting of forms imbues her work with an air of refinement.

At present there are few artworks in China which espouse an overt women's consciousness. This is due to the fact that for a long time Chinese women have been disadvantaged in daily life and through received principles of art and self-restraint. The situation that women face hinges on and will be determined by the definition of self. This definition must be established within a conceptual framework which confronts and deconstructs past theories concerning women. If this does not occur, women will fall into the trap that has been created for them by the dominant male debate and, as has always happened in Chinese history, male artists will continue to create their own images of women. (There are also female artists who paint in this manner.) Despite the fact that female artists have begun to question and move away from these stereotypes, the power of male supremacist art which arises from traditional culture means that the development of women's art in China will continue to face difficulties and challenges in the future.

[1] This sculpture was made by B. N. Muchina for the International Exposition held in Paris in 1937. It was 24 metres high, weighed 5 tonnes and was made from stainless steel.

Translated by Claire Roberts

Xu Hong is an artist and writer who works in the Art Research and Acquisition Department at the Shanghai Art Museum.

sex and sensibility

women's art and feminism in korea

kim hong hee

Women's art has come to be recognised as a vital and important part of contemporary art in Korea, signifying more than simply 'art by artists who happen to be women'. This advance in the positioning of women's art in the Korean art community has been manifested in the increasing number of professional women artists and their dynamic engagement with the activities of the art world, as well as in the ways in which womanhood and gender are represented in their artworks.

Nonetheless, the critical problem in any debate about women's art in Korea centres on the assimilation of feminism by women artists. The acceptance of feminist art has been made difficult by the sociocultural context of Korea, and more directly by the disposition of the Korean art community towards feminism. This has created a fissure between women's art and feminist art, and therefore a major task for those involved and interested in the role of women in Korean art is to bridge the divide between women's art and feminist art. This essay intends to examine the place of women in contemporary Korean art and to provide a basis for further study on the prospects for feminism in the Korean art community.

HA MIN-SOO, **I am a King, I am XY, 1993,** cloth with stitches, 190 x 230 cm.

CHUN KYUNG-JA, Legend, 1961.

Early art history and women's art: 1920–1960s

The presence of women in Korean art history begins early this century with Na Hae-Suk, Baek Nam-Soon, Chung Chan-Young and Bae Jung-Rae, all of whom were professional artists. There are only a few surviving works by women that predate the early modern era, including those by Shin Sa Im Dang from the early Chosun Dynasty (1392–1910) and her daughter Lee Mae-Chang, the poet Hur Nan-Sul-Hyun, and the *kisaeng* from Pyung Yang, known as Jook Hyang. However, their artistic activities were marginal and only Shin Sa Im Dang has been accredited with some surviving works. So it is fair to state that women did not have a place in art history before the turn of the century; the beginnings of modernity in Korea.

Unlike the women of the Chosun Dynasty who were bound by the conventions of a Confucian society and its moral codes, which would have made it difficult for women to work professionally, the women artists of early modernity travelled abroad to Japan to study art just as men did, and they practised as professional artists by exhibiting with the Sun'jun exhibition[1] and established the first professional women artists' groups. There were many women artists in the generations following those early pioneers. Among the most well known are Park Rae-Hyun and Chun Kyung-Ja who started working in the 1950s; Kim Jung-Ja, Lee Soo-Jae, Bang Hae-Ja, Moon Mee-Ae from the 1960s; followed by Won Moon-Ja, Suk Ran-Hee, Hong Jung-Hee, Choi Wook-Kyung – names representing half a century of women in the history of modern art in Korea. But strictly speaking, the art that was practised by these women artists was neither feminist art nor art about womanhood. Certainly there were individual differences, but most women artists were not conscious of the gender issue in art and simply adopted the art modes practised by male artists. Hence, before feminist art had an opportunity to be explored, women artists were contributing to further expanding the mainstream that was dominated by male artists.

These women who practised art were therefore not involved with women's issues, but among the many women artists from early modern art history Na Hae-Suk and Chun Kyung-Ja require special mention because they are two exceptional individuals who worked in different modes from those which were prevalent among women artists. Na Hae-Suk, who has been noted as the forerunner in women's art, produced academic landscape and portrait paintings which were adaptations of contemporary male artists' work. She was a woman with an incredible feminist consciousness, a professed suffragette and dedicated feminist in her own right. Through her published poetry titled *Nora*, about liberation of the female sex, and through her writings, she proclaimed that women must take the initiative and challenge the conditions of daily living in order to be liberated from household labour and to develop one's potential.

Chun Kyung-Ja was a like-minded soul but not as full blooded a feminist as Na. Chun represented the issues of women through her art. Working within the context of mainstream art, which was dominated by gender-blind academism and modernism, Chun developed a unique personal language that expressed a feminine realm of fantasy and she deserves recognition as the first true feminine artist. These two women artists indicate how difficult it is to find a synthesis between sexual politics and feminine/feminist art and the following generation of women artists would recapitulate the failings of this fissure. When the consciousness of an artist like Na can be represented visually in artwork, and when the feminine paintings of Chun find a strong critical voice a forceful feminist art can be formulated.

Modernism and women's art: 1970s and 1980s

As was the case in the West, the hegemony of modernism did not account for women's art but would only accommodate the work of women artists that assimilated the language of the modernist mainstream dominated by male artists. The important women artists that emerged during the 1960s, 1970s and 1980s hopped on the bandwagon of male-oriented modernism, and did not have the intention or feel the necessity to cultivate a female consciousness, but worked somewhat as anti-feminists or non-feminists. Their greatest goal was to produce work that was evaluated as being 'as good as any male artist', and not be scorned as being inferior art because it was by a woman. In such circumstances, it was only natural that there were successful individual women artists, but this was not conducive to the development of feminist art. Even during this period there were women artists who produced works dealing with feminine subjects, such as Chun Kyung-Ja, and women such as Choi Wook-Kyung doing abstract paintings in colours and shapes that alluded to a feminine sensibility. There are also those artists whose work intersects the border between feminine art and feminist art, such as Kim Won-Sook or Kim Myung-Hee. However, these artists cannot be labelled feminist since their art represented a feminine sensibility without gender consciousness or sexual politics.

Yet women's art during the reign of modernism in Korea did establish a tradition of feminine art that referred to or paralleled feminist art, demonstrated by activities of the Expression group which was formed in 1971. The women artists of the Expression group were modernists and also semi-feminist in orientation. Through their group activities they were the first activists to profess feminist art to be their primary agenda. They announced 'perseverance' as their motto, in defiance of the limitations and constraints imposed on women artists, and adopted the term 'expression' to represent their intention to acquire a voice for themselves as women artists. Their work started with abstract and conceptual formal investigations, working with themes such as *tae-guk*

KIM WON-SOOK, **Man and Woman, 1993**, oil on canvas, 167 x 121 cm.

below: **KIM MYUNG-HEE, Rape of Sabine, 1986,** charcoal, crayon pencil on paper, 64.5 x 99.5 cm.

opposite page: **YOU YUN-HEE, In the Train of Thought, 1994,** acrylic, paper relief, 115 x 115 cm.

(mandala) or black and white. As their collective experiences accumulated, their work came to deal with more pertinent themes such as the domestic. Their early paintings in oil were in the abstract expressionist mode which was later transformed into decorative pattern paintings, using materials such as cloth, thread and a variety of textiles. In looking back over the past twenty years, the members of the Expression group say that they first came together to survive as artists and were not so much bound by a sense of solidarity as feminists. They cannot be easily categorised as feminist artists since they lack any allegiance to gender politics, and also because their work reveals a rather antiquated attitude of equating womanhood with the family or motherhood, which disregards the role of women today in society. Nevertheless, this group was different from other groups of women artists in that they worked with a collective consciousness, and during the 1970s, when modernism was dominant in the art world, their appearance paralleled the emergence of feminist art activities in the United States. The Expression group has earned recognition as the first women's art movement in Korea, as they focused on art by women, creating a pivotal point for women's art. It is regrettable that before this group was mature enough as a collective to deal in depth with issues of gender politics, by the early 1990s it had regressed to formal investigations and metaphysical subject matter. The remaining members include You Yun-Hee, Sohn Bok-Hee, Lee Sun-Ock, Park Young-Wook, Yoon Hyo-Joon, Kim Hyung-Joo, Noh Chung-Ran, Kim Myung-Hee, Lee Eun-San, Kim You-Jin and Kim Jee-Myung.

Minjoong art and feminist art: 1980s

A new phase in women's art and the emergence of feminist art came about in the late 1980s, around the time of the staging of the 'Women and Reality' exhibition (the first feminist art exhibition) in 1987, with the formation of Yuh'mee'yun (Women Art Research Association) that was made up of women artists affiliated with the Minjoong art movement. Minjoong art came to the forefront in the early 1980s as an oppositional movement against modernism and concurrent with the wave of post-modernism that emerged by 1988 as a new cultural ethos. These movements and the Seoul Olympics disrupted the hegemony of modernism and inserted alternative art activities and anti-modernist aesthetics which provided the context for the birth of feminist art in Korea.

Yuh'mee'yun, formed in 1985, was a specialised branch of the national network of Minjokmi'sul Association, which was a visual art component of the Minjoong art movement. It brought together various smaller organisations, namely Tuh (Site) with Jung Jung-Yup, Choi Kyung-Sook, Koo Sun-Hwe, Shin Ka-Young, and the October Group with Kim In-Soon, Kim Jin-Suk, Yoon Suk-Nam and also Kim Jong-Rae and Moon Saem. These artists began by critiquing the modernist notion of art as an autonomous field that had alienated art from real life, and based their politics on a neo-Marxist notion that art is meant for everyone and must not serve as marketable merchandise solely for the upper-middle class. Forty non-professional women artists participated in the 'Women and Reality' exhibition which critiqued the wrongs that affect women in everyday life. The exhibition was a historic event as it was the first public feminist art event to be held and it provided a stage for discussions about feminism and the arts. The members of Yuh'mee'yun were encouraged by this exhibition and came to be increasingly dedicated to the cause of raising feminist consciousness through feminist art. They intended to do this through staging the 'Women and Reality' exhibition annually, embracing an increasing number of working women artists, and as a platform to engage collaboration among the farming community, the working class and professional women artists, thereby serving as a medium for solidarity between communities and social classes.

The feminist art that centred around the activities of the Yuh'mee'yun was basically a branch of the Minjoong art movement and therefore shared the historical significance that Minjoong art has in Korean art history, as well as the artistic trappings of Minjoong art. As with Minjoong art, the feminist art that was affiliated with Minjoong art was historically a significant phenomenon: the art produced by these women was not an assimilated variation of a western mode but was rather born within the context of Korea, and was therefore a native movement and evidence that a feminist art pertinent to the realities of Korea could exist. However, since Minjoong feminist art was derived from the politics of the Minjoong movement and not from artistic necessity, there was no central artistic tenet or methodology but rather a snug adaptation of the Social Realism that was the official style of the Minjoong artists. Therefore these women artists were labelled as women Minjoong artists before really maturing as feminist artists. And the primary concern for the Minjoong women artists was not feminist art per se, nor the investigation of the instruments of sexual discrimination or of women as victims of such discrimination, but social injustice and class. These artists were concerned with the problems of women in the lower socio-economic class as victims of class structure in a capitalist society. These artists therefore collapsed gender politics with class. The neo-Marxism of these artists resulted in a lack of

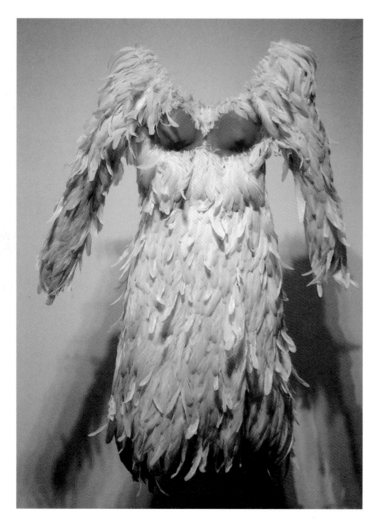

commitment to problems of womanhood/gender and art. However, it is through their initiatives that feminist art has achieved a grounding in Korea. Recently these artists have changed as they have come to grips with the trappings of Minjoong women's art, and as they engage with different and novel means of expression and ideas, trying to re-invent themselves and also including a younger generation of post-modernist women artists and thereby expanding the boundaries of feminist art in Korea.

Post-modernism and women's art: 1990s

It might be too early to discuss the presence of so-called post-modern feminism without either post-modern art or feminism firmly estab-lished in Korea. Within the context of the Korean art community, where there has been little understanding or serious comment on fem-inist art, it is probably beyond the capacity of contemporary Korean art to incorporate feminist consciousness and gender politics into the realm of post-modern aesthetics, which is still in its introductory stage. In Korea, both feminist art and post-modernism emerged in the 1990s. Since modernism was antithetical to feminism and Minjoong art, and since the politics of Minjoong art did not produce a successful partnership with feminist art, the concurrent emergence of post-modernism and feminist art has apparently become a variable discourse for accommodating feminist politics.

What then does post-modern feminism refer to? Post-modernism is basically a male-dominated discourse and feminism is a discourse on the liberation of women. The two differ in many tenets but nevertheless intersect and agree on various points. The primary point of agreement between post-modernism and feminism is that the marginalised Other in the discourse of post-modernism includes, among other communities, women. The pluralism in post-modernist discourse acknowledges women as the subject, as the 'I', elevating the previously marginalised status of women to the centre in the subject position. The collaborative project of post-modern feminism works as a cultural critique and thereby expands the previously narrowly defined feminism as ideology into a feminism as intellectual discourse; a feminism as political activism into a feminism as cultural activity; a feminism on egalitarian rights into a feminism for differences.

There are not many women who could be labelled as post-modern feminist artists. Among the few are the performance artist-cum-instal-lation artist Yi Bul, the installation artists Park Hae-Sung and Lee Soo-Kyung, photographers Hong Mee-Sun and Kim Jung-Ha, the members of the Yuh'mee'yun, Cho Kyung-Sook, Suh Sook-Jin and Yoo Joon-Hwa, and the few artists who are more post-modern than feminist, such as Hong Soo-Ja and Kim Myung-Hae. An encouraging sign is that although these artists are few in number, they have shown remarkable

energy and output, and accordingly the future of women's art and feminism in Korea does not look all that bleak.

Apart from the post-modern lineage in the context of women's art during the pluralism of the 1990s, there are a substantial number of a younger women artists who have expressed genuine interest in feminist art while rejecting the rigid sexual politics of modernism, inventing diverse methods of expressing feminine or feminist issues. Among these are the Hyung'sang (Figurative) group, who synthesised feminism and formalism and whose members include Kim Nan-Young, Park Kyung-In, Kim Choon-Ja, Lee Jung-Hyun, Lee Hae-Joo; another is the 30 Carat group, with members in their thirties whose work reaches beyond the conventional realms of feminist art, and includes Kim Mee-Kyung, Park Jee-Sook, Ahn Mee-Young, Yum Joo-Kyung, Lee Sung-Yun, Lee Hyun-Mee, Lim Mee-Ryung, Choi Eun-Kyung, Ha Min-Soo, Ha Sang-Rim. The 30 Carat group has conducted collaborative investigations and study projects and continues to exhibit as a group. It is the activities of this younger generation of women artists that will shape the future course of women's art in Korea.

Women's art in contemporary Korea

Women's art in Korea since the late 1980s has been shaped by the presence of modernism, Minjoong art and post-modernism. As feminism or feminine art interacted with the male-dominated mainstream, women's art has demonstrated a range of politics and aesthetics which is at present opening up to new emergences. But there is not yet a dominant women's art or feminist art that can define the issue of women in the visual arts in Korea. The presence of women in the Korean art community is still dominated by successful women artists whose works are largely variations of mainstream male-oriented styles, coupled with semi-feminist artists who have developed a feminine sensibility in their work without making any pronouncements regarding gender politics. There is no consolidated feminist art movement and although there have been random incidences of artists practising feminine or feminist art, these efforts have not come together in the form of a collective movement or in activist political engagement. Have Korean women artists truly confronted the institutionalised forms of discrimination within the art world and the unjust treatment of women artists? Women artists are included here and there like last minute decorative pieces to participate in group exhibitions, but have there been strategic efforts to fight this situation? Have women artists questioned the curatorial practice of overseas exhibitions that predominantly show male artists? In Korea, Minjoong feminist artists took a confrontational position against the mainstream, but their target was class struggle and not gender politics in the art world. Other groups that followed did not confront practices in the art community or fight to change the existing

opposite page top: **YOON SUK-NAM, Story of Mother, 1995**, acrylic on wood.

opposite page below: **YOO HYUN-MI, Dress with Breast, 1993**, feather, cloth, 119 x 66 x 12.5 cm.

below: **KIM NAN-YOUNG, Simple Life, 1991**, acrylic on canvas.

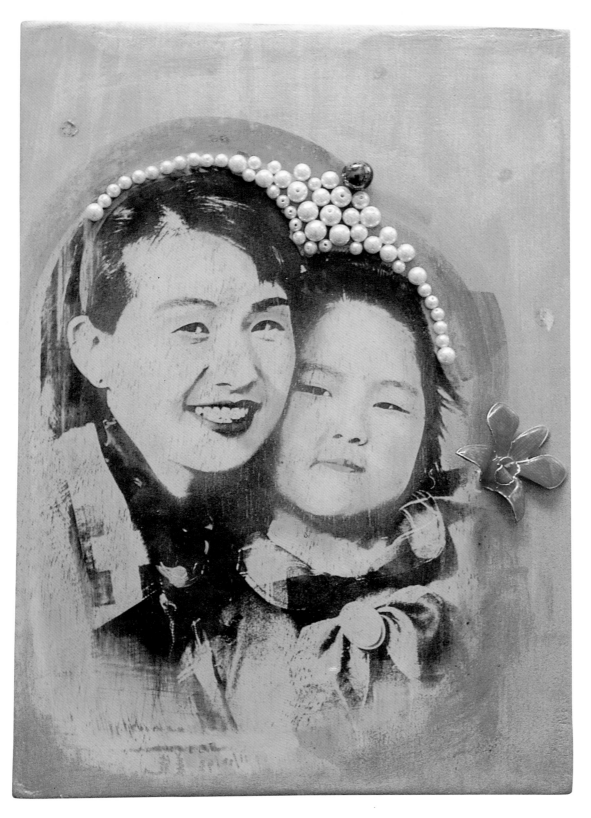

HONG MEE-SUN, Icon, 1993,
(detail) photography on wood,
mixed media.

opposite page: SUH SOOK-JIN,
Happy Woman, 1993, copy on
paper, 52 x 36 cm.

inequalities. It is because feminist art and gender politics in Korea have not been able to come together as a consciousness-raising movement that feminist art has not matured nor gained momentum.

The aforementioned problems, namely the fact that there has not been an adequate feminist consciousness or feminist aesthetic, cannot be separated from the context of Korean society. Various societal factors have been disadvantageous to the establishment of feminism, which emerged in Korea some twenty years later than in Europe and the United States, and today still act as a barrier against the further development of feminism in the arts. What then specifically are the anti-feminist societal factors?

The first factor is the long-held conventions of Confucian thought and behavioural codes. Since ancient times, in both East and West, paternal lineage has been the dominant form of organisation. In the case of Korea, the phallocentric ideals that men are the sole heir to the family and the leading actors in society have further engraved paternalism onto the Korean psyche. According to Confucianism, the differentiation between male and female is not only that of sex but is part of a universal order – just as north, south, east and west are different points on the compass that shall never meet, and as birds of a feather flock together in the animal world, civilised human beings are also differentiated by class and gender, and such are natural givens. Accordingly, discrimination against women is not an abstract phenomenon, but an inevitable reality and women were made to accept this factor. In such circumstances, feminism is perceived as disruptive of natural laws and norms – a vice that goes against conventions – and for some Korean women, to accept sexual discrimination and learn to become numb to it, could be the only option. Korean women did not have to fight for the right to vote and for political participation, which was accepted en masse with the adoption of modernity from the West, and by the modernised and westernised elite men of Korea. Therefore the first women activists and the women who received a modern education did not know of the necessity for women's rights activism, but were wholeheartedly devoted to the national agenda of modernisation. Since the adoption of modernity and change at the turn of the century, the women of Korea have not produced a prominent feminist movement or a noteworthy feminist culture.

The second anti-feminist factor is education, as art education in Korea is detrimental to feminism and women's art. The majority of female students in Korea have followed the convention of majoring in

the liberal arts and, particularly, the visual arts and music attracted women students as feminine disciplines for cultivating one's taste. If one looks into art education, the curriculum does not favour independent research into women's art. The problem today with art education seems not to be sexual discrimination, as it has been in the past, but rather the negligence towards gender differences.

The third factor is the rigidity across disciplinary boundaries and genres that exist in Korean academia. As there hasn't been great engagement among the visual arts, literature, music, theatre, film and other areas, women in these creative fields have not had the opportunity for critical debate and in-depth discussions on women and gender issues. If women in the visual arts had been more informed and aware of activities by women conducted in other disciplines, feminist art would have had a much earlier start and would also have had a support system outside of the art community. There is also urgent need for cross-fertilisation among disciplines such as women's studies, social studies and anthropology.

These have been the main factors outside the art community that have bred an unhealthy environment for feminism and feminist art in Korea, but, obviously, the most detrimental factors have come from within the art world since feminists have not received support from within the art community, and even those few practising feminist artists have difficulty sustaining their work.

Art historians must go back to rewrite the histories of art, to carry out excavation work in search of the place for women and women artists in the history of Korean art; rewriting an alternative history of art to supplement and correct the male-dominated art history that has been practised. In art criticism there needs to be a different language for discussing the work by modern and contemporary women artists, different categories for evaluation, and theoretical groundwork for discussing women's art and gender politics within the context of Korea. The task is to overcome the barriers and restraints of the hegemony of modernism, the ideology of neo-Marxism or the discourse of postmodernism, and to create a personal language, a voice that is truly representative of womanhood in Korea.

1 An annual juried exhibition established by the Japanese Governor-General during colonial occupation of Korea.

Translated by Roe Jae-Ryung

Kim Hong Hee is a Korean art historian and writer.

the aesthetics of cultural complicity and subversion

yi bul

james b. lee

In early September of 1994, the Korean installation and performance artist Yi Bul (Bul Lee) was being interviewed for a program to air on a new channel aimed at the women's market, one of thirty new stations that will begin broadcasting as Korea enters the age of cable TV in the spring of 1995. The segment of the interview in which the artist was asked to give a self-assessment of her work had gone through four or five retakes, when the director, a man in his forties, with credits that included programs for the government-run KBS, finally said, 'Couldn't you be a little more deferential and humble? We want our viewers to like you.' Yi Bul's response was to deliver, straight-faced – though not without a trace of self-conscious irony – audacious self-praise. 'As far as I know, no artist in Korea today is producing work that's as interesting as mine,' she stated. 'I think my work is excellent, though consistently underrated.'

A telling incident in many ways, it brings to light the lingering patriarchal cultural expectations regarding women in contemporary Korean society, and the strategy of resistance and subversion practised by Yi Bul as a woman artist in such a cultural context. Korea may soon have cable TV, but it's not likely that images of women shown on the new expanded channels will vary from the existing media representations that serve largely as passive embodiments of male desire. This incident from

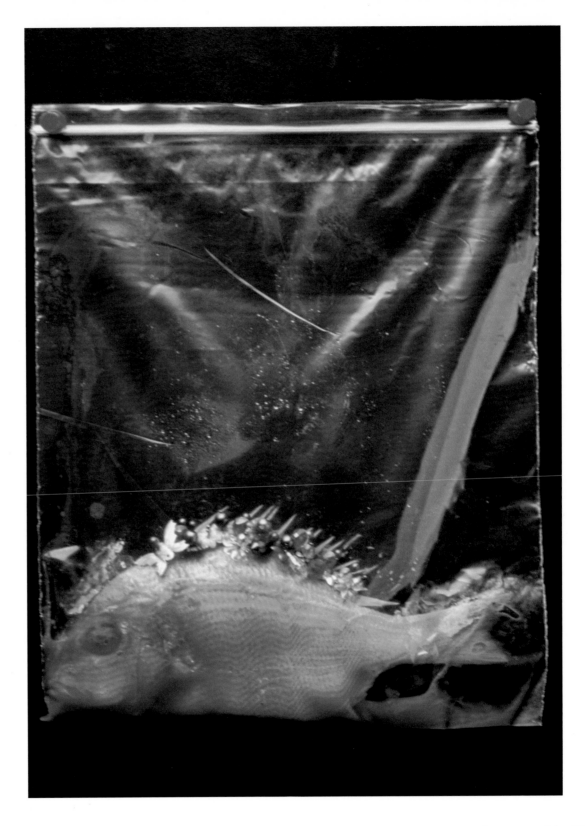

YI BUL, Majestic Splendour, 1993,
(detail, from a series of 60) fish, sequins,
pins, plastic bags, 15 x 20 cm.

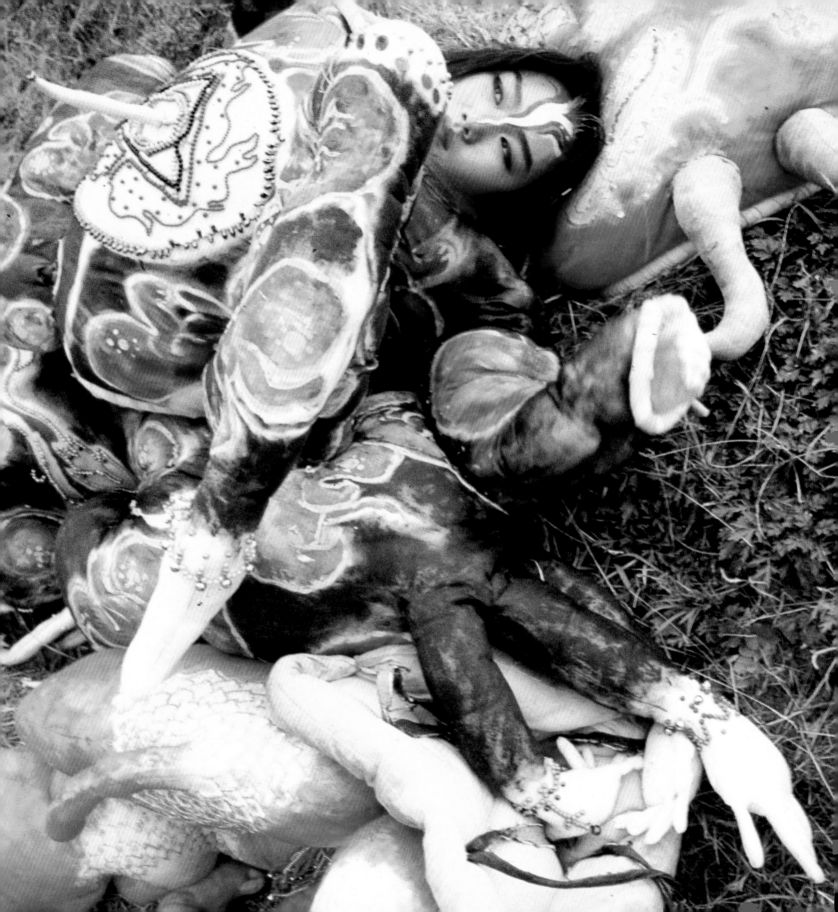

her interview, as with much of Yi Bul's art itself, can be seen as 'doubly encoded', to borrow critic Linda Hutcheon's term: the artist participates in an activity precisely in order to destabilise its conventional function and meaning. Yi Bul may present herself to the gaze of the TV camera and implicitly acknowledge its power to fix her as an image for mass consumption, but she will not be recuperated by it. In short, she won't sit still and be a good little girl.

Born in 1964 to parents who led fugitive lives as political dissidents, Yi Bul has made a career of confronting, exposing and undermining the forces of cultural and political ideologies, deeply rooted in the particularly Korean brand of Confucianism, that continue to maintain the silence of women and the dominance of male authority in Korean society. Beginning with works like *Abortion*, 1989, a performance which stirred up controversy for its nudity and its examination of a social issue long deemed taboo; and *Cravings*, 1989, which featured the artist and three other performers donning her 'soft-sculpture' pieces – full-body suits constructed of sewn fabric padded with foam rubber to exaggerate and distort the anatomy of the wearer – and rigged with hidden microphones that simultaneously amplified and 'dehumanised' the sound of their laboured breathing accompanying a series of intricate, butoh-like movements, she has positioned her art at the emerging edge of the cultural curve, and in the field of public, even mass, discourse.

Never having subscribed to the discredited notion – still upheld in some quarters of the contemporary Korean art scene – of the privileged status of aesthetics, Yi Bul self-consciously implicates herself in the very cultural conditions she critiques in her work. Take, for example, a recent feature article in a glossy, mass-circulation women's magazine called *Young Lady*. There, among the diet tips, recipes, advice for the marriage-minded and countless advertisements for women's clothing and cosmetics, are photos of her performance from 'Woman, the Difference and the Power', 1994, a group exhibition of Korean women artists. The photos show her nude, except for a dog collar around her neck, connected by a chain to a metal bedframe. She holds aloft a pick-axe, poised to break the binds of domesticity, sexual submission, or whatever the audience chooses to read into the act, but in any case going about it the hard way. The point of the performance, as she explains in the article, was voiced by an audience member who called out, 'Just undo the dog collar!' The absurdity, and the paradox, of the situation was that an obvious solution was right under her nose, literally, but overlooked precisely because it was so apparent. Simply put, the performance can be said to be an allegory of the master–slave dynamic with a decidedly feminist inflection: the enslaved is held

opposite page: **YI BUL, Cravings, 1989,** outdoor performance, Jang Heung, Korea.

captive more by the internalisation of her condition of subjugation than by any external constraint.

Of course, this simple irony is extended and complicated when the photos of the performance are placed in the context of a woman's magazine whose purpose is the promotion and the marketing of largely male-manufactured notions of feminine desirability. Do these images of the artist, nude, without make-up, and in a pose of defiance, function to contravene the endless variations on the 'beauty myth' taking up the bulk of the magazine's pages as ads for facial creams and depilatories, lipsticks and lingerie, liposuction and weight-loss centres? Or do they unwittingly become complicit in the commodity logic of mass media, deprived of their oppositional force and rendered safe for easy consumption by the reader, who can experience a brief, vicarious thrill of transgression against patriarchal conventions before moving on to the fashion spreads and contemplating the purchase of a new outfit?

Yi Bul sees such contradictions and ambivalence as not only unavoidable but integral to the activist aim of her aesthetics. 'For my work to speak to a larger audience, on whatever level, beyond the small art-world coterie, it's often necessary to use the means of mass media that may also reinforce ideologies that my works challenge,' she says. That she has frequently provoked the interest, and sometimes the outrage, of various media, ranging from KBS, the major daily newspapers and women's monthlies to such unlikely ones as *Christian Korea*, *Sports Chosun*, and *Businessmen's Quarterly*, attests to the relevance of her work to the issues and concerns in the culture at large.

Majestic Splendor, 1993, an installation of fish adorned with sequins, beads and pins, became the subject of a flurry of media attention, much of it directed toward what one newspaper described as the work's 'repulsiveness'. There was also the quarrel between the artist and the gallery owner, who demanded, when the decaying fish began to cause a stench, that the installation be dismantled earlier than was planned. The work was jarring, and perhaps even repulsive, to viewers who were accustomed to encountering the fish, *domi* or red snapper, only in markets and on the dinner table, and certainly not in various stages of putrefaction under the unsparing halogen lights of the gallery. And what were they to make of the gaudy decorations, the sequins, the plastic beads and the steel pins glittering amidst the decomposing flesh?

The work (a slightly different version simply entitled *Fish* was exhibited at the 1993 Asia-Pacific Triennial in Brisbane, Australia) is open to multiple layers of interpretation. On a theoretical level, it can be read as an example of Derridean critique of oppositional distinctions. The fish serve as an embodiment of the natural, which has historically been exalted and romanticised as a manifestation of the universal, the eternal, and thus privileged over the artificial, the inauthentic. *Majestic*

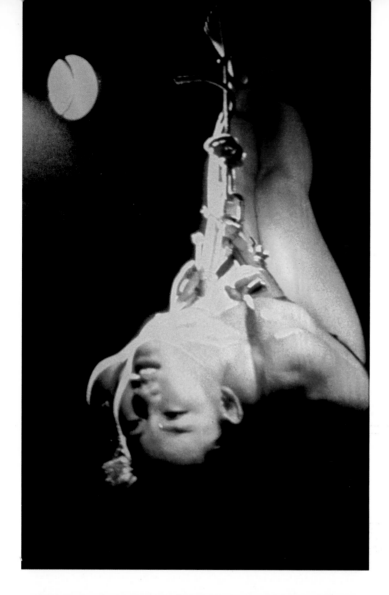

Splendor calls into question the stability of such categorical concepts: in an ironic reversal, what remained of the work after the ten-day exhibition were the cheap man-made ornaments, the fish having undergone, literally and metaphorically, a 'deconstruction' revealing their skeletons, the framework of their composition.

The work is also specifically, if not conspicuously, feminist in its use of materials like fish and sequins, which are conventionally endowed with feminine connotations in Korean culture as in many others. In Yi Bul's appropriation of these materials into an aesthetic context, they no longer remain merely the stuff of cooking and sewing, housework and handicraft, activities that have long defined the boundaries of women's social identity. Crossing over from the domestic to the public realm, they assert an unspoken cultural history of women in Korean society while simultaneously indicting the dominant patriarchal ideology that has produced the oppression and inequities that are a large part of that history.

For those familiar with Korean legends, *Majestic Splendor* has an additional subtext. As Yi Bul recounts it, there once was a young woman whose beauty so beguiled the king that he sent her betrothed to the battlefield and schemed to possess her for himself. Steadfast in her devotion, the young woman, upon learning of the death of her betrothed, commits suicide rather than succumb to the king's seduction. The name of this tragic heroine, Lady Domi, is virtually synonymous with what the legend commemorates as the height of womanly virtue: absolute, self-abnegating fealty to a man.

'Most people find it a beautiful story,' says the artist. 'But when you consider its deeper implications, it's not only ridiculous but disturbing. This woman guards her virginity at the cost of life itself, yet this sort of insistence on feminine sexual purity is still enduring in Korea and has damaging consequences for many women. To cite extreme cases, it's not uncommon to hear stories of girls who, when their first sexual experience doesn't finalise in marriage, feel "tainted" and fall into prostitution.'

In *Majestic Splendor*, the sparkling trinkets – ironically echoing the tapestry of Homer's faithful Penelope – inscribe upon the decomposing *domi* a sad testament to Lady Domi's immaculate virtue, while their cheap, artificial status debunks the questionable ideal of womanhood embodied in the legend.

Yi Bul's examination of the ambiguous boundaries between the authentic and the false, the natural and the artificial, and the cultural operations of such distinctions continues with *Alibi*, 1994, a set of objects formed of translucent silicone, cast from a mould of her hand. Trapped within each of these remarkably life-like hands is a butterfly

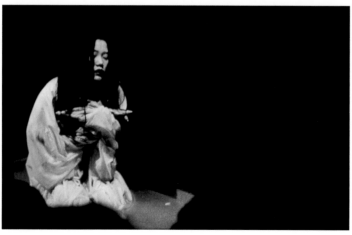

top: **YI BUL, Abortion, 1989,** (performance) Dong Soong Art Center, Seoul.
left: **YI BUL, The Song of the Fish, 1990,** (performance) Dong Soong Art Center, Seoul.

pierced through with a long glittering hairpin of the sort once favoured by Korean courtesans. Here, as in *Majestic Splendor*, the artist juxtaposes natural and artificial materials to produce a contradiction or a cancellation of their conventional meanings and associations. Both the silicone replicas of her hand and the butterflies, dead but preserved to appear eternally in flight, suggest that the conventional terms used to distinguish the authentic from the contrived may no longer be valid in our age of processed reality, amidst the proliferation of what Baudrillard has called 'simulacra'. Yi Bul is concerned with exposing or subverting the concealed contexts of cultural inventions, especially those relating to issues of gender and sexuality. After all, what could be a more satiric metaphor of the lingering western fetishisation of the 'Oriental' female than the butterfly, with its subtle yet undeniable reference to Puccini's famous opera, held forever fixed, with wings spread for the viewer's gaze, on the sharp tip of a courtesan's hairpin?

A similar kind of deconstructive impulse has been at work in her performances as well. For instance, *The Song of the Fish*, 1990, is an interrogation of archetypal, or 'mythic', images of women which recur in fables and legends, and continue to inhabit the public imagination. The work presents three unsettling variations on such archetypal images, an innocent little girl, a murderous empress, and the artist herself as a grief-stricken young widow, each engaged in a repetitive, almost obsessive, activity that suggests borderline madness. The young widow, for instance, methodically disembowels by hand one fish after another.

These images are recognisable because their cultural function is to serve as symbols, with meanings that are publicly codified and constant through time. In short, they are myths, but as Roland Barthes has observed, it is the particular characteristic of myths to disguise the circumstances of their production: they derive their authority by assuming the guise of the universal, the eternal. The artist believes that many mythic images of women, like the ones in *The Song of the Fish*, are largely male-constituted, and that the symbolic meaning often precludes what she calls 'the real stories, the private stories of women'. She explains that by interjecting elements of the personal and the private into these images, she sought to displace some of their public, consensual meaning. 'The figure of the grieving woman was meant to be especially unsettling because it was partly an expression of my own private anguish at the time. I think that made the image somewhat unfamiliar, and the meaning was no longer just symbolic. There was now some other, undefined meaning that the audience could sense, though never fully come to know.'

top: **YI BUL, Woman: The Difference and the Power, 1994,** (performance) Hankuk Museum, Seoul.

right: **YI BUL, Untitled performance, 1994,** Myong-dong streets, Seoul.

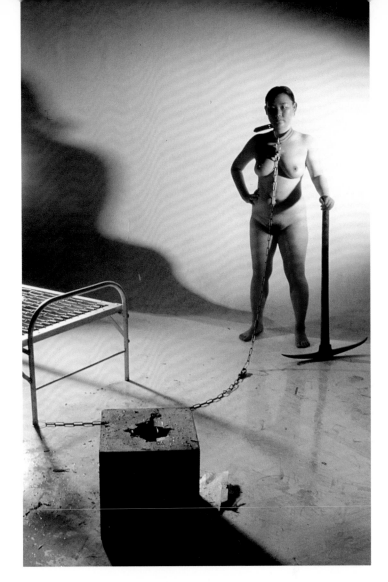

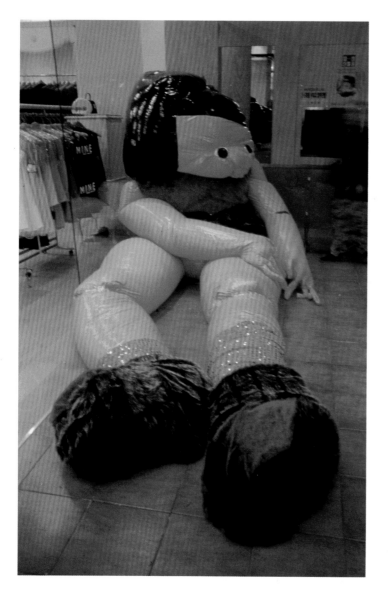

The Song of the Fish also emphasises, precisely in order to expose, the dubious roles traditionally reserved for women in myths, as embodiments of unreason, passion and madness – forces which must be subjugated. When one considers the fact that psychoanalysis began as a therapy for women and that Freud himself formulated many of his theories within the borrowed framework of Greek myths, the artist's claim that the 'universal' meaning of myths can often be exposed as a patriarchal construction becomes quite persuasive. Yi Bul elaborates: 'No one really questions why myths mean what they mean. The meaning is simply a given, and it's accepted. I'm saying that the meaning isn't so universal, that it's always in the service of some kind of cultural or political agenda.'

In her latest works, Yi Bul has shifted her critical attention to the public dissonance between art and commerce. It seems inevitable that an artist of such insistently activist aesthetics would eventually come to examine perhaps the single most dominant determinant of contemporary culture: money in all its myriad manifestations and workings. In the West – as the signal example of Warhol made it abundantly clear – the production of culture, both high and low, has evolved along with the ascendance of the logic of capitalism; whereas in Asia, especially in countries like Korea that have only recently undergone an accelerated process of industrial and economic development, the arts have maintained a disavowal, mostly disingenuous, of the market forces. As Yi Bul sees it, such a stance of denial smacks of the hermeticism of high modernism which led to the isolation of art from the social context. 'Today nothing can escape the influence of money or economics,' she says. 'It's neither something to lament nor deplore, but simply something that artists must face up to.'

Thus, in 1994, she created the series *The Visible Pumping Heart*, and conducted an auction as a performance at the exhibition opening. As she announced to the gallery audience, the objects in the series – including a winged female torso, an enlarged model of an anatomical heart, and an androgynous doll, all intricately ornamented with sparkling beads and spangles in her trademark fashion – were created (and neatly packaged in attractive acrylic cases) with the express purpose of making them saleable and, as she ironically added, 'to complement any home decor.' She then determined the starting bid by calculating the number of hours spent making each object: the gesture was both an acknowledgment and a self-conscious parody of the concept of art as commodity. By the end of the 'performance', she had managed

left: **YI BUL, Untitled installation, 1994,** vinyl, fabric, fake fur, 4 x 2.5 x 2 m.

opposite page above: **YI BUL, The Visible Pumping Heart I, 1994,** mixed media, 40 x 40 x 60 cm.

opposite page below: **YI BUL, The Visible Pumping Heart II, 1994,** mixed media, 40 x 40 x 60 cm.

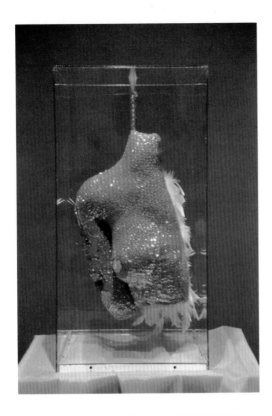

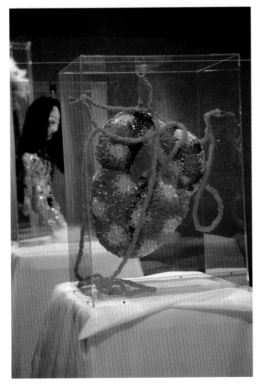

to auction off not only her art but even the dress she was wearing for the occasion.

Writing in the Korean monthly *Art Plaza*, critic Yong-Jae Lee said of the event, 'It was unprecedented in the Korean art scene, because it was an open violation of the implicit proscription against publicly speaking of money and art in the same context.' In other words, the collusion of art and money had always existed in Korea, only now Yi Bul had brought it out into the open, into a field of larger, more frank discourse.

Later in 1994, the artist was offered the perfect chance to subvert commercialism at the very site of its operation when she was commissioned by a high-priced boutique to devise a performance and an installation for its grand opening. Trading on her credentials as someone whose works were proven to attract public attention, she required that no constraints be placed on the subject or method of her creations. On the day of the store's grand opening, Yi Bul and two other performers, bedecked in outlandish garbs that were a travesty of fashion trends, strolled about the streets of Myong-dong, Korea's high-fashion, high-spending district, carrying fishing poles and 'baiting' curious bystanders to follow them into the store, where the artist had installed a 4-metre-tall doll, made of pink plastic and dressed in garish fake fur – a monster offspring of consumer culture. The performance drew to a close as the artist, in a satiric enactment of excess appetite, finished off an entire Haagen-Dasz ice-cream cake while the audience, including the store manager, looked on amused and somewhat befuddled.

'The store manager did think the installation and the performance were odd for the occasion, and complained that he didn't expect them to be so nonsensical, as he put it,' says Yi Bul. 'But I had managed to draw a crowd, he got what he wanted. But more importantly, I had achieved what I'd intended: to have art manipulate and undermine the force of commercialism, instead of the other way around.'

This sense in which Yi Bul's work seeks to point up the contradictions, the follies, and the hidden ideological operations from within the cultural context of its own construction is often ambivalent and problematic; but it also suggests that any art which attempts to produce an effective critical dialogue in relation to the social and political conditions of the culture at large must abandon the outdated notions of detached or 'pure' aesthetics, and even adopt the vernaculars of mass discourse. The aesthetics of Yi Bul, with its multiplicity of technique and reference that are closely attuned to the shifts, the proliferation, and the dispersal of information and ideology in the continuing transformation of contemporary Korean society, aspires to expand the scope and possibilities of art as an act of cultural commentary.

James B. Lee is Visiting Professor in English at Han Nam University in Taejon, Korea.

a banana is not a banana

yang wen-i

In 1975, Cho Yu-jui, a female artist who had just graduated from the Fine Arts Department of National Taiwan Normal University, submitted an oil painting entitled *Banana III* to the annual Taiwan Provincial Art Exhibition. This work, executed in a hyperrealist style, sparked fierce debate among the predominantly male jurors. On one hand, this may have been due to its photo-realistic technique, which had only recently been introduced to Taiwan and differed greatly from the impressionist and abstract styles which had hitherto dominated the Taiwanese art scene. On the other hand, it was the fact that this artist had boldly chosen a monumentally enlarged bunch of bananas as her painting's sole subject, a subject that was fraught with a certain symbolism. Unfortunately, because of these controversies, the work failed to win a positive echo among the jurors and earned only an 'Honourable Mention', while a year before the painter's entry for the same competition had been awarded its First Prize.[1]

In Taiwan during the first half of this century, bananas were considered a symbol of agricultural growth and fertility; Taiwan itself was dubbed a 'Banana Paradise'. Yet the reason why Cho Yu-jui chose bananas as her subject, as related by a friend of that time, was that 'she saw bananas as a symbol of life, from the purple-red fruits ripening between the green leaves through the emergence of the fully developed banana bunch to its being peeled and consumed and finally being buried under a curtain'.[2]

CHO YU-JUI, **Bananas VII, 1975,** oil on linen, 180 x 224 cm, collection the artist.

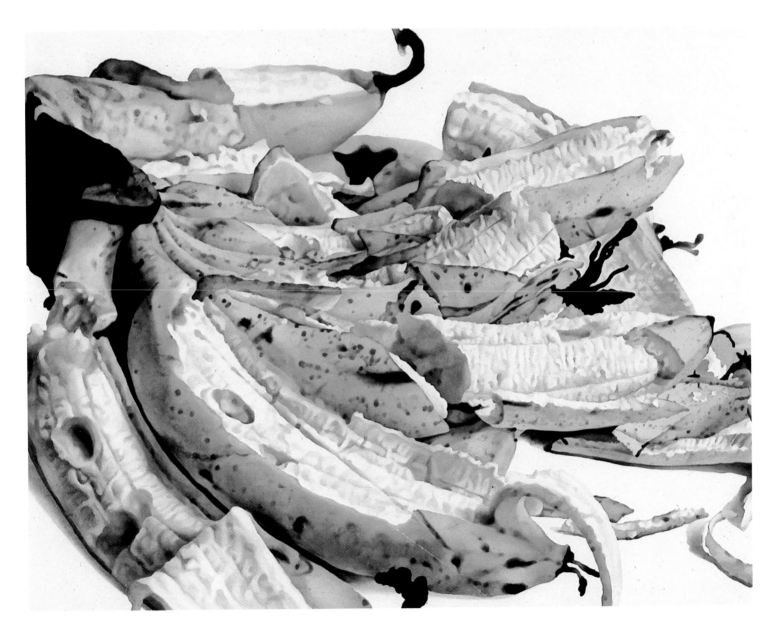

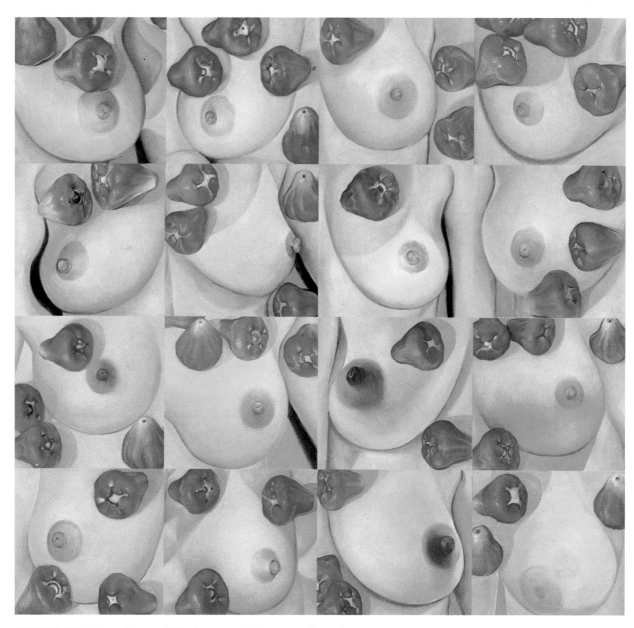

YAN MING-HUI, Fruits and Breasts, 1990, oil on canvas, 103 x 103 cm, collection the artist.

opposite page: **CHEN HSING-WAN, Work 8411, 1984,** mixed media, 107 x 450 cm, collection Taipei Fine Arts Museum.

In other words the symbolic content behind Cho Yu-jui's bananas is nothing other than life itself, an elegiac rendering of life from birth to death, of the passing of time. Here, no connection is to be found with the intentions that accompanied western photorealism, such as the elimination of subjective feelings and a reflection of contemporary technological civilisation. Yet if we reconsider the painting in its historical context, that is, the mid-1970s when in politically isolated Taiwan the so-called nativist or localist movement was flourishing, the painting takes on another meaning. In this reading, the hyperrealism is simply the best technique to objectively depict the outside world, while the banana is a fruit that Cho Yu-jui's home district of Pingtung produces in particular abundance and with which she was confronted every day when she grew up.

Fifteen years later, in 1990, Yan Ming-hui, another woman artist who graduated from the same university and department as Cho but had spent some time studying in the USA, created a painting called *This is Art*. Again, the subject of this work is bananas, but its symbolic content is explicit. Using a pluralistic visual language, the painter directly and sharply binds together a banana and its twin image, the male sexual organ, with a ribbon as if they were presents. The whole painting doubtlessly originates from feminist concepts and in a playfully satirical way takes on the subject of sexual equality and of authority in a phallocratic society. Compared to Cho Yu-jui's tentative treatment of the 'banana' subject that aims to strike a cool, lyrical balance between private experience and the search for outside reality, Yan Ming-hui's *This is Art* appears as a manifesto, opening up a new and fresh female look on society.

Women artists and feminism

Between 1975 and 1990, Taiwan experienced a number of sweeping changes. The economic miracle brought with it a higher living standard and provided the base for a stable social development. Yet under a forty-year-long half-dictatorship, an ideological dogmatism dominated the country that ended only when martial law, the ban on opposition parties and control of the press, was lifted in 1987. From then on, all sorts of value systems, whether traditional or modern, were attacked and faced a hitherto unseen degree of questioning, dissolution, reorganisation and reconstruction. The female activist Lu Hsiu-lien, who was a major participant in the opposition movement during the 1970s, was arrested by the Kuomintang government and fled the country, later not only to return secretly to Taiwan but, in 1991, to become a member of the ROC parliament. Another female activist who emerged in the late 1970s was Li Yuan-heng. During the 1980s, in addition to her long-term engagement in movements supporting those groups who are on the margins of Taiwanese society, she helped found a feminist magazine as well as foundations and other non-government organisations, continually striving for women's equal rights. In the field of literature, Li Ang, who had been a writer for twenty years, in 1983 published her famous novel *The Butcher's Wife* that marked a significant change in her writing style. Written from a feminist point of view, the novel for the first time depicted a Taiwanese woman as an object of male sexual desire who, having been suppressed and abused for a long time, finally explodes into a rage of destruction. These three 'New Women' of Taiwan come from different backgrounds and advocate different standpoints, but during the last two decades have become engaged equally in the fight for the better status of women in society.

In the field of visual arts, the work of Taiwan's women artists as a whole does not reveal an obvious strategy directed at a feminist consciousness. The previously-mentioned feminist painter Yan Ming-hui, although not the only one of her kind, is a member of a quite small minority, a few other representatives of which I shall introduce later. Particularly in the works of the conceptual artist Wu Mali, a lot of work and creative energy has been dedicated to the feminist question. As far as the creative direction of most other Taiwanese women artists is concerned, two major tendencies can be detected. One is concerned with projections of mind and soul, of inner emotions, depicting in a predominantly abstract style certain spiritual directions of the artist's psychological world and consciousness. The other tendency relies on the use of materials and images which represent the peculiarities of the female body and mind, such as delicacy, sensitivity, emotionality, and

softness, which all appear in works of art of this kind. Through the description and analysis of the works of a selection of representative female artists, I will present a few main outlines of Taiwanese women's art today.

The release of emotions versus a dialogue between materials

In the formative period of western abstract art, the two main currents were expressive and geometric abstraction. After the Second World War, the centre of the international art scene shifted from Europe to America's East Coast, a fact which was directly related to the flourishing of abstract expressionism there. It was at the height of that movement during the 1950s and 1960s that American abstract expressionism reached Taiwan via many twisted and turned ways, just at the time when local artists were searching for information on current artistic developments in the world.

The female abstract artist Chen Hsing-wan, who emerged in the early 1980s, is indirectly connected to that school. During the 1970s she studied painting with Li Chung-sheng, a formative personality in the 1950s and 1960s who propagated that artistic creativity should return to the pure essence of art. However, rather than the adoption of certain abstract styles and techniques, it was Li Chung-sheng's views on art – his non-traditional method of introducing artistic techniques to his students, the spirit of half-automatic creation he advocated and his belief in a pure artistic quest – that gave Chen Hsing-wan concrete nourishment. In the first ROC Biennial of Contemporary Painting, organised by the Taipei Fine Arts Museum in 1985, Chen Hsing-wan won the Second Prize with her *Work No. 8411*. We see its creator boldly attempting to forge a masterpiece through use of different materials, such as bars of wood, newspaper clippings, plaster and oil paint, and by making use of a combination of various techniques: application of

paint by splashing, pouring and by brush, as well as collage. Although the work reveals strong lyricism, compared to most other women artists of the early 1980s – who were either looking back to romantic girlhood feelings or were still fettered to conventional styles – it gave an example of bold artistic innovation.

In contrast to Chen Hsing-wan's search for 'new materials', for an abstraction of images, other Taiwanese women artists, such as Tang Chiung-sheng, Ava Hsueh, Yang Shih-chi and Lin Pei-chun, express their personal experiences of inner life, of existential memories, in an abstract artistic language as if in a private diary. In their works we often find a strong emotional expression, a sense of conflict, mystery and melancholy, subtly brought to the viewer's eye by way of thick, dark layers of paint and textural brushwork. Apart from Ava Hsueh, who almost unrecognisably integrates into her paintings such materials as pieces of bandage or fishing net, the other artists all work in oil on canvas. Most critics classify European and American abstract expressionism as a typically male school of art, yet in Taiwan it has been predominantly female artists who have favoured that style of painting. On the psychological level, this fact probably reflects the urge and the need of these artists who are modern women yet bound to a traditional collective consciousness to release and uncover their inner complexes.

As to fields other than two-dimensional abstract painting, Lai Jun-jun and Cynthia Sah concentrate on three-dimensional plastic works which have attracted much public attention. During the 1980s, Lai Jun-jun actively furthered the development of modern art in Taiwan and with friends founded the 'Studio of Contemporary Art' (SOCA) to promote exhibitions of installation works and other art forms. In her own work, Lai Jun-jun started out with two-dimensional abstract paintings in the hard-edge style, then made the areas of colour become

opposite page above: **LAI JUN-JUN, Being and Transformation, 1986**, mixed media installation, collection Taipei Fine Arts Museum.

opposite page below: **AVA HSUEH, Untitled, 1990**, mixed media on canvas, 152 x 228 cm, collection the artist.

below: **CYNTHIA SAH, Untitled, 1991**, marble, 240 x 52 x 64 cm, collection Taipei Fine Arts Museum.

non-defined and applied them to three-dimensional forms such as plexiglass plates and bars of styrofoam, fully bringing out a specifically female floating of soul and mind. In recent years, Lai's attention has shifted to the expression of the magnetic responses between natural materials of different form like wood, bricks or sand. Some of these works reveal a high sensitivity to visual language.

Another artist expressing herself in pure form is Cynthia Sah. Yet the materials she chooses for her creations are traditional ones: marble and bronze. In her sculptures, just as in those of Lai Jun-jun, the viewer recognises an artistic idiom that is emotional, delicate and elegant; but the main theme of her works is a balanced handling and mutual dialogue between the hardness of traditional materials and floating, curved lines, between rest and movement, fullness and emptiness.

Mali's self-portrait and Margaret's clouds

During the last decade, Taiwan's society, politics, environment and value system have faced serious challenges. Confronted with such unsettling and disturbing surroundings, how should artists respond? Should one internalise the turmoil of the present situation by transforming it into spiritual images of colours and forms? Or should one respond directly with works carrying a definite message, with criticism, subversion and satire? Among Taiwan's female artists, the previously mentioned feminist painter Yan Ming-hui has assumed a blatant stance, strongly attacking traditional notions of male and female roles. Other activists in that vein include Hou I-jen and Fu Chia-hun. In contrast, the focus of the works of Wu Mali and Margaret Shui Tan is not necessarily limited to feminist issues, but makes some distinct statements closely related to our social and cultural environment by way of symbolic forms or metaphorical transformations.

In her 1993 solo show at Taichung's Contemporary Gallery, Wu Mali exhibited two models of a Daihatsu car and a Mercedes in their original size and design, one clad in golden plastic foil, the other in aluminium foil, and added another, smaller Daihatsu model painted phosphorescent pink. These three cars were placed around the exhibition room in the way car dealers present their commodities. Yet in this car show strategically devised by an artist we see the symbols of Taiwan's leap from a Third World country to an industrially advanced nation that was brought about by the economic miracle of the 1980s. Each car carries symbolic meaning: the gold-clad Daihatsu car ironises the 'sacralisation' and legitimisation of wealth; the aluminium-covered Mercedes, entitled 'Proletarian Car', presents an ironic reversion of form and substance, while the small third car, which looks like a loudspeaker car blasting political messages but has an irritatingly bright colour, causes a sense of disorientation between power and sex (the female sex). At the feet of these three toy-like models the artist placed a

below: **LIN CHUN-RU, Crying Goblin I, 1994,** (detail) mixed media, 280 x 160 x 120 cm, collection the artist.

opposite page: **MARGARET SHUI TAN, Strategy of Clouds, 1994,** (detail) ceramic and wood, 25 x 25 cm, collection the artist.

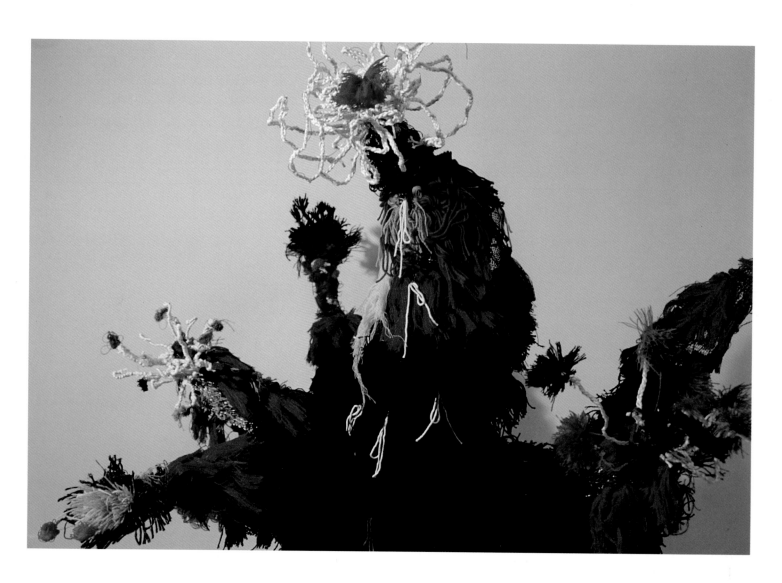

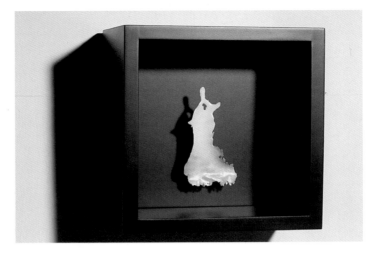

'cute', tiny unnamed object, a two-wheeled axle moving about automatically by some electronic device. According to Wu Mali's own words, this is meant to be a self-portrait, just as the artist moves actively, yet under cover like a guerilla fighter, amid the delusions of brand-name worship, manifold reversions of words and meanings, disorientation and delusion.

This installation work, entitled *When a Pickup Meets Super Mary*, is a manifesto that strongly shows an artistic individualist's rational reaction and self-assertion as she is confronted with the absurd structures of politics and society. In the last ten years, from her participation in activities commemorating the democracy movement around the lifting of martial law in 1987 to her co-founding the group 'Taiwan Documents Room' in the 1990s and her recent involvement in feminist issues, social criticism, the subversion of conventional values, and the breaking up of traditional patterns of thinking have been the central points of Wu Mali's installation works. In *Gnawing Texts and Reaming Words*, her entry for the Taiwanese exhibition in the 1995 Venice Biennale, she shredded books from which she formed a library, that 'repository of knowledge', thus responding with biting satire and deep reflection to the uncertainty of human spirituality in the face of today's information explosion.

In contrast to Wu Mali's intellectual and rational criticism, in Margaret Shui Tan's works, which first gained notice at the end of the 1980s, delicate porcelain clouds often form the main subject. Her creations are filled with social consideration, sensitivity, a motherly care and a sense of beauty. In her recent works, she indirectly describes, with a subtle personal sensibility, the relationship between man and nature, a relationship that contains the possibility that man may rise above his environment and enter an aesthetic and spiritual level. In *Strategy of Clouds*, each of thirty-six fine and beautiful porcelain clouds placed in

black boxes symbolises in its form, according to the artist's own testimony, a person or an object close to herself. The title of the work alludes to the 'Thirty-six Strategies' in traditional Chinese thought, which are various methods of escaping certain crises and difficulties. In the light of present-day Taiwan's ever-worsening environment and its unending social and political turmoil, this work clearly expresses the close connection between the artist's personal existence and her artistic creativity.

Taiwan's contemporary female art is still at its starting point and continues to develop strongly. Apart from those artists briefly introduced in this article, each year there are more than ten women artists who finish their university education in Taiwan, go abroad for further study and return to their native land to become active in full-time creative work. Among those who have returned during the last three years are Chiu Tzu-yan and Lin Chun-ru. Local artists like Chen Hui-chiao and Lien Shu-hui have recently emerged in the Taiwanese art scene. Each of these artists creates strong works in a distinctly female artistic language. Given these developments, there should be little doubt that in the coming century Taiwan's female art scene will produce talents and creative achievements to a degree only decades ago few would have dreamt of.

1 'Cong Pingdong de xiangjiao dao Suhe de poyuan canou: fang chaoxieshi huajia Cho Yu-jui' ['From the Bananas of Pingtung to the broken walls and deserted corners of Soho: An interview with the photorealist painter Cho Yu-jui'], *Hsiung-shih Magazine*, October 1991, pp. 144–9.
2 'Cho Yu-jui: kehua sixiang de xin xieshizhe' ['Cho Yu-jui: the new realistic painter depicting thoughts'], *Artist Magazine*, December 1975, pp. 98–103.

Yang Wen-i is a former curator at the Taipei Fine Arts Museum.

poised in equi

introducing the work of irene chou

anne kirker

Since Irene Chou (Zhou-Luyun) moved from Hong Kong to Brisbane, Australia in early 1992, her painting has maintained the stylistic hallmarks, innovation and single-minded focus that have earned her wide international recognition. She is a product of the New Ink Painting movement spearheaded by Lu Shoukun in the 1970s which steered the classical Chinese ink painting tradition in Hong Kong towards abstraction and an engagement with Western styles. Artists from this movement included Wucius Wang, Wu Yaozhong and Laurence Tam. Theirs was a struggle with a long and illustrious history of imagemaking which began as a composite art of painting, calligraphy and poetry, and which since the twelfth century was bound up with the single theme of landscape.

In situating the individuality of Irene Chou, one writer points out that:

In the many visual manifestations of Lu Shoukun's followers, landscape remains the dominant theme. Only a few of Lu Shoukun's students venture into more abstract realms. Lu Shoukun's abstraction in his philosophical painting inspired Irene Zhou (Chou) to examine the dynamic energy of the single cell and regenerative life forces.[1]

In fact, Irene Chou was less a disciple than a contemporary of Lu Shoukun, and he would often work in her Hong Kong studio. Arguably, she evolved the most distinctly individual style associated with the New Ink Painting movement.

librium

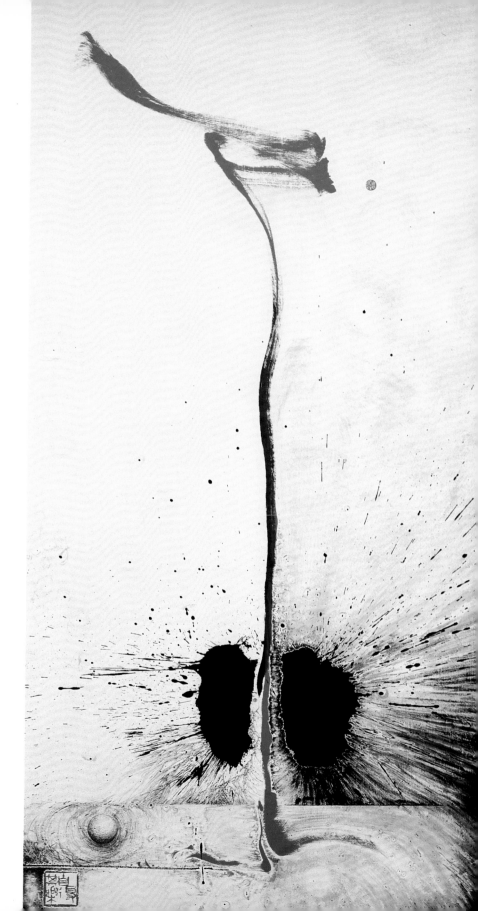

IRENE CHOU, Infinity Landscape, 1987, Chinese ink and colour,
134.5 x 66 cm, private collection.

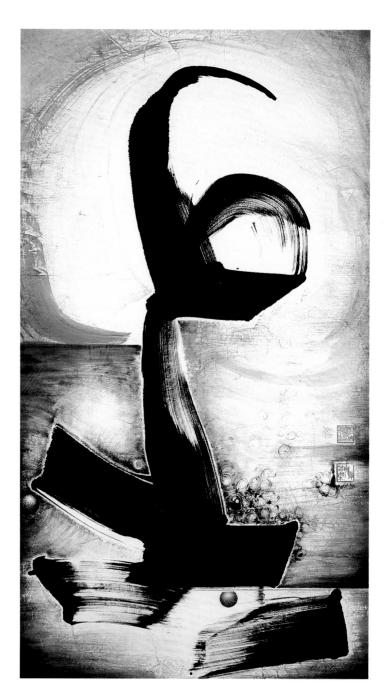

IRENE CHOU, **The Story of Time and Space, 1990,** Chinese ink and colour, 180 x 90 cm, private collection.

Born in Shanghai in 1924, Irene Chou's parents were radical intellectuals who had a keen interest in music and art, and it was from her mother that she learned Chinese calligraphy. She graduated in economics at St John's University, Shanghai, in 1945 and afterwards practised journalism for a short time, working as a reporter for the *Peace Daily*. The founding of the People's Republic of China in 1949 turned the traditional Chinese cultural structure on its head and like many others Chou immigrated to Hong Kong. She married and became preoccupied in the home, raising three children.

At this point the impulse to express herself creatively became an urgent imperative and she commenced study in the Lingnan School of Chinese painting (1950–59). Her first teacher was Zhao Shaoang. Although the Lingnan School adopted principles of impressionism and a relaxed and popular form of Chinese ink painting, it was still the norm to learn by copying the master's work. Following Zhao Shaoang's example, she emulated his branches of blossom, bamboo and intricate studies of nature, but increasingly identified with Lu Shoukun's more expansive, experimental approach. During this early period she produced monoprints and Western-style abstract compositions, as well as personalised, often humorous, interpretations of early Chinese paintings in albums (of Buddhist monks, for example), endeavouring to break from the practice of slavish imitation.

During the 1960s, her painting activity increased and she read extensively, attending courses in literature, art and philosophy. Her first solo exhibition, at Hong Kong's City Hall in 1968, demonstrated a nascent talent exploring a variety of Chinese and Western styles with no particular clarification of direction. The work that she developed over the next decade became more focused and formally consistent.

To reach this point she looked closely at archaic calligraphic scripts inscribed on bronze vessels from the Shang and Zhou dynasties and started painting 'line works' in a subdued range of tones with spherical seed-like forms. Allusions not only to calligraphy but to landscape and the natural world were implicit. 'I make the lines and subconsciously the landscape comes out – in a movement from the ground to the mountains and to the sky,' the artist explains in retrospect.[2] The scroll format of these works further emulated Chinese tradition, although building up the composition of parallel lines involved a total physical engagement ('action painting' in a sense), as she walked around, across and through the image with the brush. *Composition*, dating from the early 1970s, is typical of these concentrated line works.

The fluctuating linear rhythm of Chou's paintings in the 1970s was sometimes integrated with vegetal shapes reminiscent of trees and veins. These tended to coalesce into spherical forms. In one of these works, *Remembering Mr Lui*, she paid homage to her former colleague whose death occurred in 1977, a year before that of her husband.[3]

These sombre, introspective statements are referred to by the artist as her 'black pictures' and testify to emotional turmoil and depression. To alleviate financial hardship, she became an art instructor in 1976 in the extramural studies department of the University of Hong Kong, continuing her teaching until 1984.

By this time, the artist had become totally reliant upon her own resources, converting her Hong Kong apartment into a studio in order to maximise the time spent on painting. She regularly practised *qigong* meditative exercises and avoided superfluous social engagements. Although in her contemplative urban situation the direct experience of the natural environment was very restricted, she responded to cyclical patterns such as observing the changing phases of the moon and also began to cultivate an interest in the galaxies and outer space.

Infinity Landscape, 1987, is one of a number of images confined to red and black which demonstrate a newfound independence and assertive vigour. With her adaptation of calligraphy into a bold abstract art, Chou found a purity of form and expression which was highly idiosyncratic. Here, the minimal brushstrokes are graceful and elegant; elsewhere, as with *The Story of Time and Space*, 1990, the gesture is broad and emphatic. She refers to this painting as employing an expansive stroke to 'stretch time and space together'. In association with the abstract calligraphic gesture, Chou also devised her so-called 'impact' textural stroke, achieved by splattering ink on the paper surface. 'You have to use wet rice paper and a rod against which the brush is tapped,' she explains. This explosive, spontaneous gesture is a counterpoint to the strong calligraphic ideograms and more detailed painted passages of her compositions.

Small modulated spheres, described by Chou as 'my inner self', are now recognised as a distinctive leitmotif of her mature work. The perfect circular form encompasses notions of the ideal and the absolute, a spiritual embodiment of love and sincerity, of beauty and tranquillity. It is also, as Lucy Lim points out, 'an image of wish-fulfilment, of romantic longings, of mystical escape that remains always stable and serene in the midst of fluctuations and turmoil'.[4]

Highly subjective, Irene Chou's ink paintings are arrived at without preliminary sketches or planning. She works from intuition and instinct and frequently her imagery from the 1980s and after suggests a personal cosmological order. Chang Tsong-zung opens his essay on the artist in 1989 with the observation: 'Cosmic storms whirl in the boundless heavens, dark and unknown. Stars glow and wane, galaxies shift.'[5] However, it is the method of *Ch'an* (meditation) Buddhism which is the more accurate guiding principle to her approach. As decreed in Taoism, to which it relates, she seeks to give visual form to a state of 'both being and non-being, a whole comprising interactive opposites: the cosmic yin and yang forces; the natural poles of life and

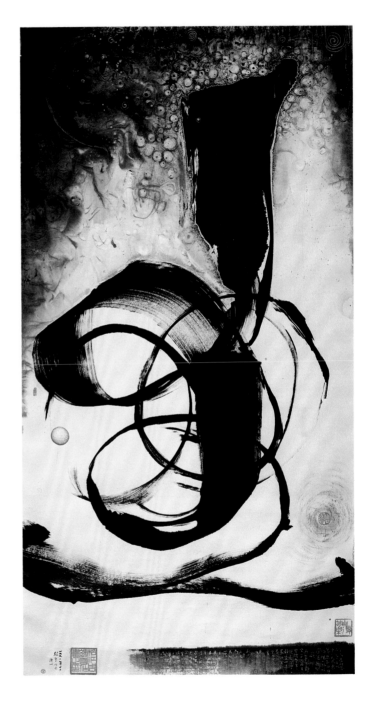

IRENE CHOU, The Universe is Within our Hearts II, 1992, Chinese ink and colour, 187 x 96 cm, collection the artist.

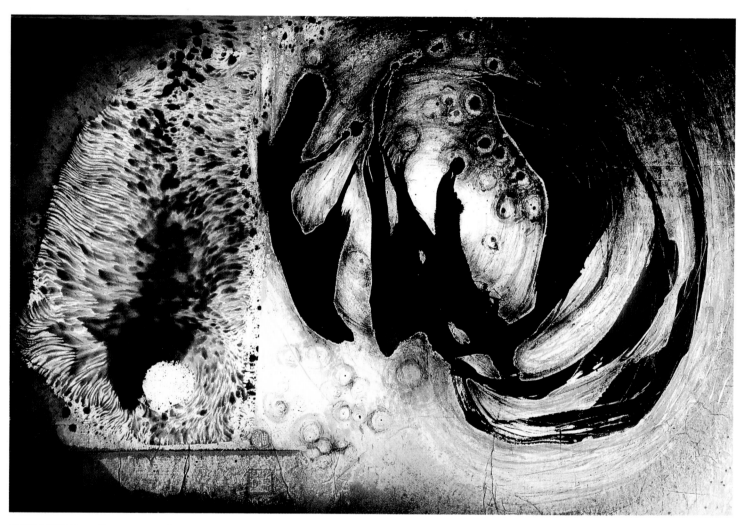

IRENE CHOU, Yin and Yang II, 1991, Chinese ink and colour, 107 x 154 cm, collection the artist.

death, light and dark, heat and cold; and the human contrasts of joy and sorrow ...'[6] *Coda*, 1990, for example, with its swirling spheres and network of bright colours in the top portion and weight of blackness below, is suggestive of a mystical duality. Works to which she gives the title *Yin and Yang* from the early 1990s further underscore this focus.

The practice of traditional Chinese meditation has undoubtedly enabled the artist to develop the strength of brushwork that is the foundation of her two paintings which were featured in the first Asia-Pacific Triennial of Contemporary Art at the Queensland Art Gallery. Given the title *The Universe is Within our Hearts*, these works were produced in Brisbane during late 1992 and communicate an exuberant joy. Chou sustained a stroke in Hong Kong several months previously and the move to Australia has resulted in no loss to her creative talent. Her use of the large Chinese brush, as in *Ch'an* (Zen) art, the vestiges of an organic presence in intricate areas of paint, and the small textured spheres often set at the beginning of a sweeping brushstroke are still clearly evident.

In terms of Irene Chou's career, the Triennial adds to a distinguished record achieved over two decades. In Hong Kong she belonged to the In Tao Art Association and the One Art Group. She held solo exhibitions in Hong Kong from the 1970s onwards and has exhibited internationally in Manila, New York, Hamburg, Tokyo, Melbourne, San Francisco and London. She is represented in prestigious public collections such as the Hong Kong Museum of Art, National Arts Centre, Taipei, Taiwan and the British Museum, London. As an indication of the high esteem in which she is held in Hong Kong, Irene Chou received the Artist of the Year Award in 1988.

1 Christina K. L. Chu, 'Some Perspectives of Ink Paintings by Hong Kong Artists', *Ink Paintings by Hong Kong Artists*, exhibition catalogue, Hong Kong Museum of Art, 1988, p. 27.
2 In conversation with the author, 29 August 1993. Unless otherwise stated, all quotes are from this source.
3 Reproduced in *Chinese Paintings by Irene Chou*, exhibition catalogue, Fung Ping Shan Museum, University of Hong Kong, 1986, p. 72. This publication includes an autobiographical account of Irene Chou and illustrates forty-seven paintings which cover four decades of activity.
4 Lucy Lim, 'Six Contemporary Chinese Women Artists: Their Artistic Evolution', *Six Contemporary Chinese Women Artists*, exhibition catalogue, Chinese Culture Center of San Francisco, p. 25.
5 Chang Tsong-zung 'The Inner Realm of Irene Chou', *Paintings by Irene Chou*, Hanart 2 Gallery, Hong Kong, 1989.
6 Robert Galbreath, 'A Glossary of Spiritual and Related Terms', *The Spiritual in Art: Abstract Painting 1890–1985*, Los Angeles County Museum of Art, 1986, p. 387.

Anne Kirker is Curator of Prints, Drawings and Photographs, Queensland Art Gallery, Brisbane.

japan

flowers for wounds

yuri mitsuda

The artists I am introducing in this essay have been chosen not because they share conceptual or stylistic tendencies, but because they are all women who began to exhibit professionally in the 1980s. For forty years after the war it was impossible not only for a woman but also for a man to make a living as a contemporary artist in Japan. Women were regarded as earnest hobbyists or amateurs rather than as professional artists; female artists practising in the generation before those discussed in this article were treated as anomalies. Before the 1980s Japanese female artists who made names for themselves either participated in groups which were conspicuous for their activities or practised values imported from overseas. An example of the former is Atsuko Tanaka of Gutai (Embody) group; of the latter, Yayoi Kusama. Yoko Ono fits into both these categories.

In the 1980s, when Japan was at the height of its economic power and had become one of the wealthiest countries in the world, women were accepted into the workforce. During this period, there was a strong trend to spend disposable income on culture. Consequently, what had been an isolated and small contemporary art community became commonly acknowledged for its ultra-modern, intellectual and, to the general public, incomprehensible qualities. This economic affluence gave both women and contemporary art a position in society. Although contemporary art was freed from its

LEIKO IKEMURA, Alpenindianer, 1989,
acrylic on canvas, 127 x 88.5 cm.
Photograph Yoshitaka Uchida,
courtesy Satani Gallery.

inhibited status, it almost became consumed by its fashionable image, which was fuelled by funds and exhibition spaces provided by publicity departments of companies and by columns in amusement magazines. It can be argued that in comparison with the past, when participation in the fine arts was limited to a specialised group, this new image of contemporary art is 'feminine'. If a highly commercial industry (such as the automobile industry) is seen as the muscular body, contemporary art can be seen to embody 'feminine' qualities, relying for support on the masculine body. If culture is a 'feminine' activity, then even women are welcomed within it. Whether this is good or bad, the era in which modern female artists could not participate without suffering social alienation or engaging in conflict has ended. On the other hand, the more the media successfully markets female artists as fashion symbols and the more opportunities women artists have to exhibit their work, the more they suffer an invisible suppression that did not exist in the past.

Toeko Tatsuno (b. 1950) is one of the few leading women painters who began exhibiting in the 1970s. While conforming to formalist painting theory she created her own sensual language from abstract patterns, and through tactile images produced a tenacious body of work. It can be said that Tatsuno was the first woman to successfully establish herself as a professional artist without belonging to any of the main fine arts groups or by importing her reputation from overseas. The reason she has attained such a status may be that she assimilated the aspects of contemporary American modernist art theory that were most acceptable to the Japanese art world.

It could be argued that the most earnest wish of the Japanese fine art practitioner over the past one hundred years has been to create works of art which conformed to European and American fine arts theory and were at the same time original. As long as the concept of fine arts itself is understood as the product of modern Europe, artists of Japan must be alienated from it. For a long time Japanese artists have been placed in the 'feminine' position (whereas for the Chinese, arts were essentially 'masculine' in the premodern era), and in the modern and contemporary art arena Japanese artists have to be content with the 'feminine' position in their relationship with Europe and the United States. Because contemporary art theory is the result of European masculine ideology, this has contributed to the exclusion of Japanese women on two counts.

This is not the case with Leiko Ikemura (b. 1951), who studied fine arts in Spain and has exhibited successfully in Germany. With regard to her work, it might be better to describe Ikemura as a German artist rather than saying that her reputation has been imported from abroad. Although she distinguished herself when 'new painting' was in vogue, it is obvious that Ikemura's mythical, awe-inspiring imagery has a personal basis which differs from the post-modernism of 'new' painting. She goes into self-imposed solitude in an attempt to transcend the ego. The essence of existence (which we could call 'ether') is drawn out and presented by her just as it is. The power of art enables one to reach to the world of 'ether', where the individual dissolves. Her decisive faith in dealing with modernism, despite recognising its failure, seems to derive from somewhere other than Japan – an oriental country that does not have a tradition of self-expression.

The individuality of Ikemura, and of Tatsuno, is not considered contradictory in a European context. However, Miho Akioka (b. 1952) is an artist who reveals a dynamic, heterogeneous strength in the way she expresses herself. For nearly twenty years, Akioka has concentrated on reproducing a single tree in sunlight and air, a practice founded on theories of optics. I think she is an exceptional artist who has captured the contemporary reality of nature and avoided the nostalgic or symbolic. The images her works present are obtained only via camera and a printing machine. Akioka's way of relating living trees and electronics without resisting or denying one or the other differs from the form of expression that strongly asserts a message of some kind. Her screen is full of absorbing power, so to speak. She removes from the audience the various elements which contradict each other and draws the audience into the dynamic force where light and dark, substance and darkness, are mixed and reversed. This is an effective way to avoid Japonistic discriminatory prejudice, at the same time relating to traditional methods of observation of nature in Japanese fine arts.

For a time Mihoko Kosugi (b. 1953) discontinued her practice but in 1983 she formed a partnership with Yasuhiko Ando ('Kosugi and Ando') and has returned to artistic activity in the form of collaboration. Large-scale installation, which mobilises five to fifteen people (depending on the project) and uses various elements such as music, computers, video, mirrors, printed images and furniture, is an effective method of encouraging audience participation. It can also be likened to an intellectual labyrinth, full of metaphors, allegories and enigmas. Although Kosugi and Ando are not prolific – because of the way the fine arts system operates – and because exhibition outlets are limited, their works draw attention to problems and deserve greater recognition.

These four artists, who belong to the same generation, are cautious about expressing sexual, private and sensual concerns. As a result of the impact of modernist theory, which claimed that only theoretical concerns were orthodox and appropriate to contemporary art, and perhaps because elements that are related to gender were in themselves the cause of the alienation of their works, these artists tend to stick to the orthodox. But for the younger generation of artists in their early thirties, who began to practise during the period that

MIHO AKIOKA, Shadow in Sway, 1991, Japanese paper, courtesy the artist.

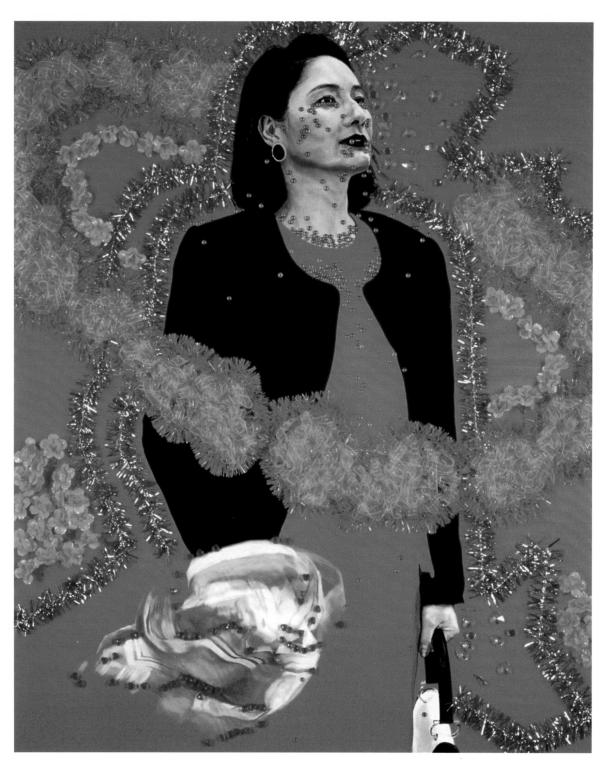

MIRAN FUKUDA, **Decoration (Pink)**, **1993**, mixed media, courtesy the artist.
opposite page: **MIO SHIRAI**, **Cut**, **1994**, black and white photograph, courtesy the artist.

contemporary art took on a 'feminine' persona, the conflict between the private and the social, the sensual and the analytical, has weakened. Yet, although they have incorporated these polarities in their work, they cannot entirely avoid distortion in their treatment of feminine images.

The households of those artists who were born in or around the 1960s (including myself) were normally dominated by a mother and two children and lacked the presence of a father, for he had to work extremely hard; consequently, daughters were brought up like sons. Since that time it has not been unusual for girls to study for an extra year after graduating high school just to get into the desired university. Gender-consciousness is weak in the families of this generation; nevertheless, women are bound by socially enforced stereotypes. Women's magazines, films and women's comics (the last sharply differentiated by sex) continue to promote sexual values from a male point of view. Qualities such as youth, beauty and fragility can be bartered for a favourable lifestyle and they give women a commercial value. Although media projection and reality do not conform, both impact upon and internalise the other, and indeed often combine intricately.

In such a case, an artist is faced with a conflict between the common female image and her sense of self. The works of Miran Fukuda (b. 1963) deal both with female models in advertisements and magazines and with the recontexualisation of European and American masterpieces. She traces, inspects and observes the unreality of the anonymous female model that is constantly reproduced and consumed. Because grand desires are imprinted and internalised within women by the fictitious world of the media, these desires cannot be banished simply by denial. However, when Fukuda looks beyond the anonymity towards regeneratation through excess ornamentation, the image which once was bland becomes offensive and begins to reveal falsity in its smiling face. Perhaps the reason why Fukuda seeks to repaint European masterpieces is to reveal the conflict of the present condition; Japanese contemporary art is always regarded as an outsider and omitted from European art discourse, even though European fine art has been completely internalised by Japanese artists. Fukuda's two types

of work are both a means to examine the self as a Japanese artist and the self as a woman who accepts and internalises the female image given by the society. Japanese fine arts and female femininity are made visible by Fukuda's works without any sense of victimisation. When Fukuda depicts the female figure, she is able to exchange wounds for flowers. That is, she is able to suggest a powerful and independent partner instead of a wounded female.

Mio Shirai (b. 1962) also deals with different images of women in her recent work. In work based on her stay in America, she depicts the different ways in which the female image is portrayed by the media and herself. She depicts the continuous conflict between the self which has a one-sided view of the female image (visual rape in the Duchampian sense), and the self which is conquered by viewing it. The image of taking a photograph of a woman who is attacking while being violated by the camera is taken from the existing media by Shirai. However, this presents an extreme conflict. I think that the mysterious presence of Eros in her works captures the complex path to the discovery of the

REI NAITO, Under the Distance,
The Root of the Light is Flat, 1989,
installation.

TOEKO TATSUNO, Untitled 93–16, 1993, oil on canvas, 162 x 192 cm. Photograph Hiromu Narita, courtesy Satani Gallery.

female Eros, expressed solely through the female figure and not directly related to men. Because female self is not independent, the Eros of the female self complies with the female figure which has always been objectified.

Rei Naito (b. 1961) is an artist who takes an opposite position to Shirai and Fukuda who are consciously confronting the mediatory female figure within the self. Her world, which is enclosed in a soft cotton cloth, requires isolation from the outer world. This quiet and purified space, which only has room for one person, is a holy womb. Inside it, remarkably delicate and subtle matters form a splendid accepting area. Naito calls this an 'unconditional blessing of existence', but wouldn't this be a holy maternity? While sketching the internal and original sensation of women, Naito has shut out the external world and made her body sensitive to extract these feelings. Because Naito's works are in a privileged position which conforms to all the connotations that the word 'womanly' had originally, and also ignores various real problems, I am attracted to it and at the same time feel rebellious. Yet, when I see her art as having the power to affect all sorts of people with the force of an innovative religion, I think it should be considered in the context of the origin of arts as ritual and religious, rather than analysing it in the framework of contemporary art.

Naito does not have the political sense that Ana Mendieta (from Cuba) had, but I think Naito sees in the interior of the human body what Mendieta sought to find in nature. Mendieta, who has lived in America, has a lot to pass on to non-European and non-American female artists. She saw through the politics of the feminist concept which supports art not from a mainstream, but rather from a feminine stance, and thereby found her original form of expression.

Nobuho Nagasawa (b. 1959) has a theme similar to Mendieta's political work and also has a similar attitude towards the power of nature. However, Nagasawa, who studied in Holland and Germany and lives in America, does not include her attributes as a Japanese person or as a woman as the main subject matter of her works. Her art is created through involvement with others rather than relationship with herself. For her, a work of art is the result of the moment of vision drawn from her presence at the place of the work's origin and the meaning of that place becomes potent. Consequently, her work resonates fully not when inside lifeless museums or galleries but when it is out in the real world where everything is actually living. She researches the location; its history, its role and significance, and events that occurred in that place. These factors are investigated and interpreted, souls are reposed and the area is reactivated for the future. Her art is similar in intent to architecture and has a strong monumentality. Yet it is not public property. Nagasawa constructs a vision of the revival of lands, which have been distorted by history and the energy required to

KOSUGI AND ANDO, Hoichi – Story and Study, 1987, installation.

admit life, by selecting subject matter that conveys the significance of the land.

I have discussed eight artists' ways of relating to production and each individual's theme, but of course they do not form a single group. The reason I have introduced them all in this article is because they are all different and they each attracted me. Discussion of which standpoint is correct and which is not is irrelevant. Journalistic questions such as which form of expression is better than another or which is or is not part of the mainstream do not have answers and are meaningless, as we have already realised that there is no common, universal or definitive area of activity that can be described as 'contemporary art'. Creating and expressing is a matter of the way we live. Communication about what each individual has obtained from life, whether it be similar or different, can be used to produce a vital 'art' of the future. I will be happy if this article has conveyed the sense of how the artists are living as women, as Japanese and the way we are living at this moment in this world where universal depression is increasing and political circumstances are unstable.

Reference
Kaori, Chino, 'Nihon Bijutsu no Jender' (Gender of Japanese Fine Arts), *Bijutsushi* (History of Fine Arts), #136, March 1994.

Translated by Yoko Furukawa

Yuri Mitsuda is a Japanese artist and writer.

traces of memory

the art of araya rasdjarmrearnsook

helen michaelsen

One is tempted to question the history and culture of woman in a really elementary way, such as: 'Where is she? Does she actually exist?' In extreme cases, many women ask themselves whether they exist. They have the feeling they do not exist and they ask themselves whether there will be a place for them at all. I speak to you from this woman's place, from her place, when she locates herself. [1]

Hélène Cixous

Like most Asian women I have been raised according to culture, beliefs and paths of the past, until one day I found that the truth as we know it changes, and the age of choice arrives. It hurts to realise that we never really make choices directly, completely independently. Because of the fact that we cannot cut loose from these socio-cultural conditions, they still have a lot of influence in my art making. I often wish I could reach that ultimate state of self-realisation: individuality through the process of making art in a natural way, much the same way I hope I can live my life naturally. [2]

Araya Rasdjarmrearnsook

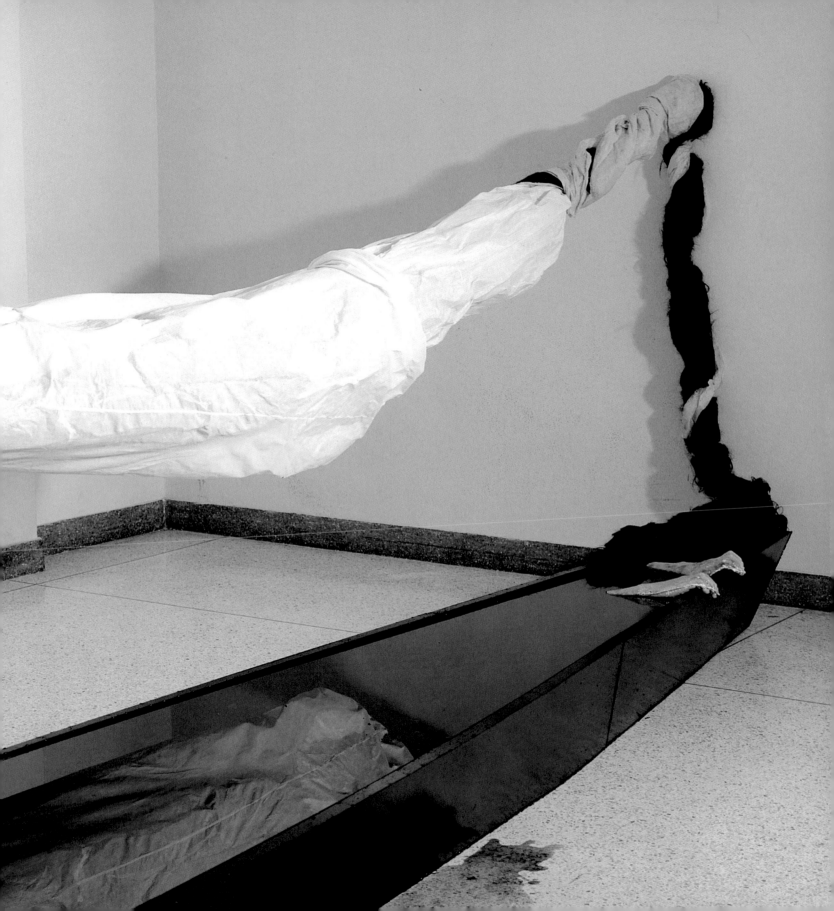

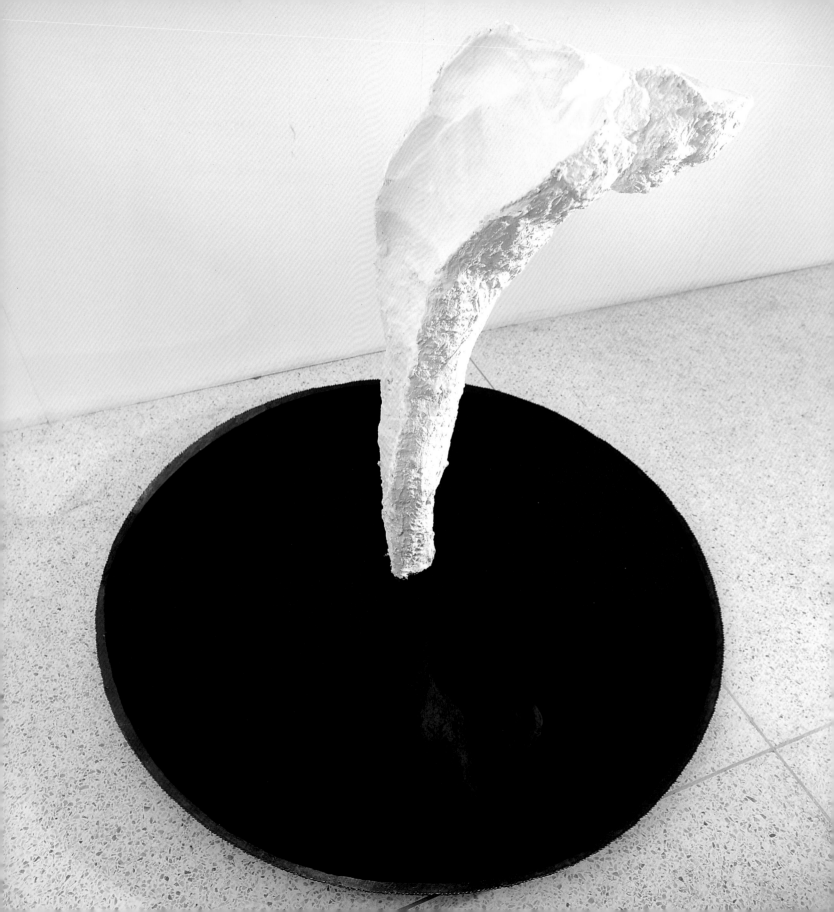

Finding exactly this place, this location of her 'self', where she can give an individual character to herself, is Araya Rasdjarmrearnsook's main pre-occupation in being a woman and an artist in Thailand. This statement by Araya sums up everything that is characteristic about her as a person as well as as an artist. Operating from the standpoint of difference, she uses precisely this language of difference to frame and decode images of women by engaging the female gaze, and thus creating images *for* women. It would be simplistic to assume that what follows in Araya's work is a presentation of a clear-cut dichotomy in which opposition towards women is of the classic dualistic, hierarchical kind, in which big and small, superior and inferior, high and low are automatically opposed.

Since she clearly anticipates that right from the beginning one is born into a 'language', and that this 'language' talks to us, dictating the laws (of society, of art, of religion), the family model, the marriage model, and behavioural patterns, Araya is well aware that sexual and political identification is both a necessity and a refusal of identification within the available visual and psychic parameters. As a result, she uses her personal history as a flow of narratives, incorporating a strong autobiographical presence in her work.

In Araya's curriculum vitae, the deaths of her mother in 1960, of her grandmother in 1987 and of her father in 1993 are listed amongst her educational and professional experiences, indicating the extent to which significant autobiographical elements are commixed with aspects of collective experience in her work.

A correlation may be found between Araya's approach and Félix Guattari's ideas on the complexity of subjectivity:

> I want to emphasise the essential pluralistic, multicentric and heterogeneous character of contemporary subjectivity ... From my point of view an individual already is a collective, a compilation of heterogeneous fragments. A subjective state of affairs always refers to personal sites – the body, the self – but at the same time to collective sites – the family, the group, the ethnic belonging. [3]

Seen in this context, Araya's work refers on the one hand to the collective reality of humans and on the other to an individual reality. By reconstructing visual and perceived language through structural analogies in the form of objects and object installations, Araya subtly expresses a reconstruction of reality, 'walking on the edge' between the zones of private and public domains, between the personal and the general.

Prostitute's Room is a work which negotiates the split between different kinds of spaces – specifically, between the open, public scenes identified with male narratives, and the closed, claustrophobic spaces allotted to women. From the outside only a black curtain is visible. The curtain serves at once as a boundary between an open and a closed area and to form an interior space: a room, a prostitute's room, a woman's space. Once inside the space, the viewer faces a glass bowl smeared with menstrual blood. For a woman, it becomes a space of two women,

previous page: **ARAYA RASDJARMREARNSOOK, Girl Says, There is Always the Night Time, 1993,** metal boat, motor oil, cloth, hair, fibre, *sa* paper, 350 x 720 x 60 cm, collection the artist.

opposite page: **ARAYA RASDJARMREARNSOOK, Isolated Hands Asking for Help, 1992,** metal, plaster, motor oil, 180 x 65 x 30 cm, collection the artist.

below: **ARAYA RASDJARMREARNSOOK, Prostitute's Room, 1994,** cloth, glass bowls painted with blood, oil, collection the artist.

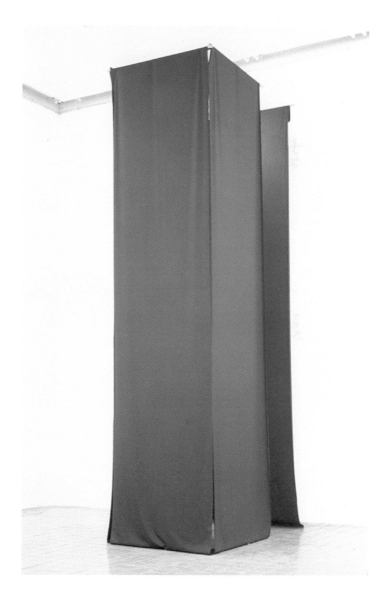

ARAYA RASDJARMREARNSOOK, Living in the Mind of Someone, 1994, installation, Braunschweig, Germany.

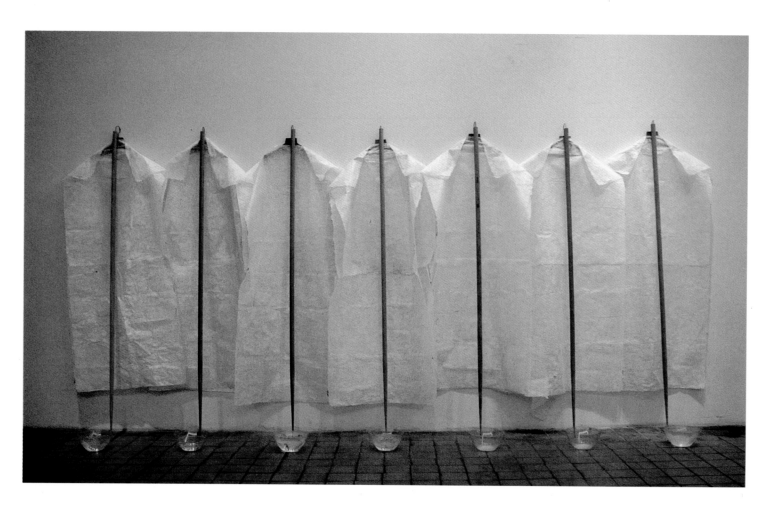

ARAYA RASDJARMREARNSOOK, **Has Girl Lost Her Memory? II, 1993,** corn, husk, metal, cloth, collection the artist.

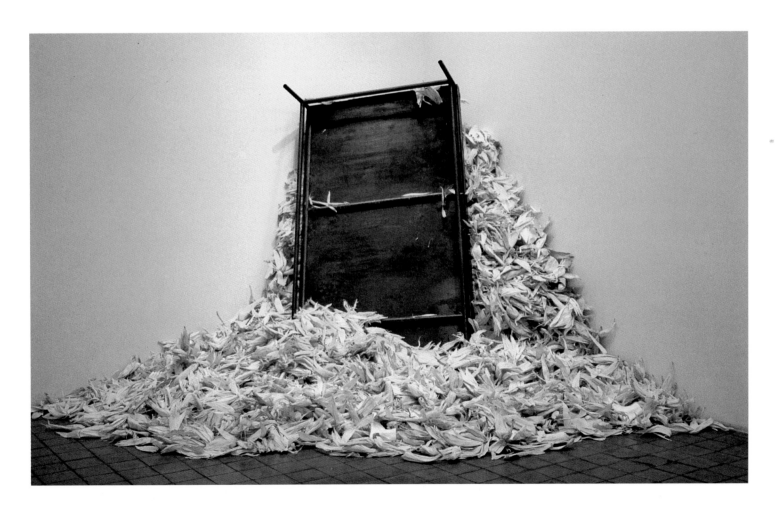

ARAYA RASDJARMREARNSOOK, The Dinner with Cancer, 1994, metal, plastic tubes, glass, water, installation, Braunschweig, Germany, collection the artist.

ARAYA RASDJARMREARNSOOK, Untitled, 1994, wood, negative film, water and hair,
58 x 92 x 12 cm, collection the artist.

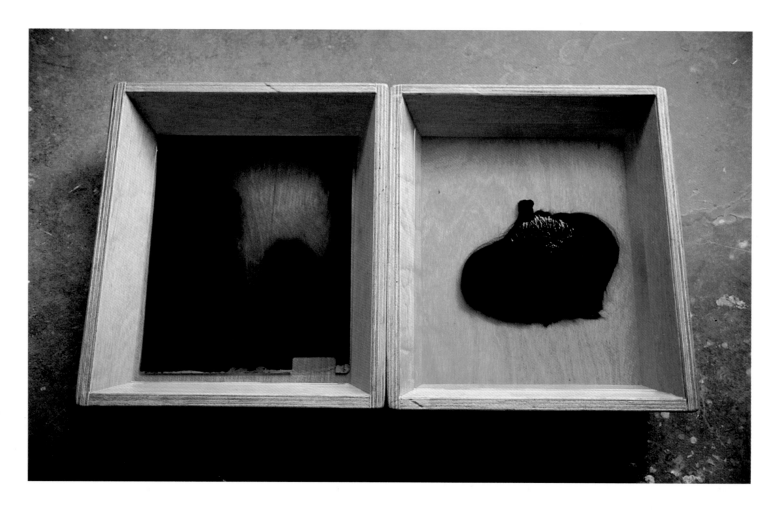

a site where the 'I' meets a 'you'. The female spectator's gaze is split in double fascination: the woman as a fetishistic object and as the space of lack and male desire. A sense of voyeurism is evoked by this intrusion into the unknown histories of anonymous women.

Araya's intrusion into unknown women's histories and lives, however, is not a mere appropriation through documentation, but rather a means of penetrating her own history. Araya's field of operation is that of memory – that which belongs to a person, to an individual history: for herself, being taught female chastity and the wife's subservient role towards her husband at boarding school; for her grandmother, having lived her life according to the ruling norms of society, raising her children and accepting the fact of a second wife and household.

The dialectic between the woman as subject and object, as spectator and as character, is brought to the fore in the works *There is but the Night Time* and *Has Girl Lost Her Memory?*. Araya describes her motives in creating these two works:

> Looking at their pictures now, I see clearly their roles within the family … whether they, as women, ever could make their own decisions and choices. *There is but the Night Time* and *Has Girl Lost her Memory?*, two pieces I created from my being both a daughter and a granddaughter, using memories of former women's roles – one may see this as a statement towards the future; memories not easy to get accustomed to: a white female body hanging up high, upside down, reflecting its shadow that travels in a large boat along black waters when time asks for its return.[4]

What is striking in these works is the way in which the problem of sexual identity and difference is posed in relation to representation. The question of gender is introduced to the visual space, deployed both as a metaphor and used as an historical reference point for the transformation of cultural and representational forms.

Owing to the nature of the objects displayed and of their presentation, for the viewer the message of the images is vague. The remembered subject remains secret; the real memory (of the artist) exists elsewhere, hidden. The only possibility for the viewer is to think of a personal mediator – a grandmother, a mother, a daughter – through which to read the epitaph chosen by Araya documenting her personal memories. As much as she hopes to reconstruct the images of her grandmother and mother for her own future, the artist knows only too well that the image of a woman in Thai society is still very much the male-created image of woman as an abstract ideal, lacking individuality.

Araya's engagement with memory can be related to the classical Greek notion of 'ars memoriae', the art of memory. In the time of Cicero it was stated that the 'artificiosa memoria', the artificial memory, is established by images and sites. According to Plato these sites enable the practice of memory in order to reach a form of understanding.

Since identity is constituted through the continuities offered by individual or collective memory, Araya appropriates the past (her memory) and the present (self-reflection) by copying memory in fragments, thus joining aspects of 'art' and 'life' in a reciprocal relationship.

For Araya, memory does not work in a linear way, but in terms of cross-overs, fragments of her own experienced space, a state, which is remembered, repeated and worked through. Personal history for Araya is a means of situating her artistic memory or 'to look at myself through my art. I took this process of introspection as a topic for my work'.[5]

The reference in the title *Narcissus* to the young man of the Greek myth implies that in this work art substitutes reality in order to inform life via subjective reality. *The Dinner with Cancer* refers to the artist's memory of her father dying. Araya has said that she created this work 'as a commentary on consumption. Humans are not only consumers, they are also being consumed'.[6]

These memories carry something from the past into the present, back to life. At the same time, they witness the bygone past, hence transience – the constant disappearance of life and so the presence of death. Traces of memory are revealed through a compilation of medical objects within a spatial context which clearly defines it as art. This configuration points to something that has passed yet left traces in the unconscious, becoming readable only through visual signs that are symbols of memory.

Pierre Bourdieu states:

> Taste classifies, and it classifies the classifier. Social subjects, classified by their classification, distinguish themselves by the distinctions they make, between the beautiful and the ugly, the distinguished and the vulgar, in which their position in the objective classifications is expressed or betrayed.[7]

Following Bourdieu's statement, Araya's choice of objects in the work *Untitled* – an X-ray and a wig – reveals respectively the artist's inner identity and her preferences in hairstyle – or art.

Araya's work is at once a mirror and a window in which the artist wants to find and claim her inner identity, using her memories so that these memories do not derive from the past, but instead make the past a result of these memories.

1 Hélène Cixous, 'Geschlecht oder Kopf?', *Aisthesis: Wahrnehmung heute oder Perspektiven einer anderen Ästhetik*, Leipzig, 1991, p. 100.
2 *Araya Rasdjarmrearnsook* [exhibition catalogue], The National Gallery, Bangkok, Thailand, 6–30 January 1994, np.
3 Félix Guattari, *Caosmose: Um novo paradigma estético*, Rio de Janeiro, 1992, p. 27.
4 *Araya Rasdjarmrearnsook*, op. cit., np.
5 Ibid.
6 Ibid.
7 Pierre Bourdieu, 'Distinctions and The Aristocracy of Culture', *Cultural Theory and Popular Culture: A Reader*, London, 1994, p. 448.

Helen Michaelsen is an art historian who has taught in the Faculty of Fine Arts, Chiang Mai University. She now teaches at the Media Museum of the ZKM in Karlsruhe, Germany.

beyond the fringe

making it as a filipina contemporary artist

ana p. labrador

The issue of hybrid identities has been receiving wide attention in the western art world recently. The exhibition 'Across the Pacific: Contemporary Korean and Korean American Art', organised by the Queens Museum in New York, stressed not only concerns about ethnicity but also awareness of questions about gender, cultural displacement, and contemporary political events affecting artists in Korea and in North America. The exhibition was moved from the Queens Museum to the Kumho Museum in Seoul, an event that prompted Eleanor Heartney to write: 'In the end, "Across the Pacific" suggests that one effect of global culture is to spread the pain of alienation across national borders.'[1]

Taking the global cultural model further, in Asian countries in which liberal economic policies are being practised some artists' and women's groups are committing their art to similar issues. Feminism is an emotive subject, even among women whose identification with it ranges from intellectual acceptance to card-carrying commitment. Given that in some Asian cultures patriarchy is dominant and feudal relationships are strong, it is unrealistic to expect even the most highly politicised Asian women's groups to move at the same pace or even in the same direction as their counterparts in the West. The value of the tenets emanating from the feminist movement in the region involves debate and critical inquiry arising from normative conventions or traditions.

In the Philippines a contradictory situation exists in which a conservative current constrains progressive ideas about the Filipina's position as artist. This tension was palpable in some of the women interviewed for this article who, while disclaiming any part in the women's movement, take pride in having achieved a measure of artistic success despite the difficulties they face in making art. A few remarked that they do not subscribe to feminism. The refusal of the label 'feminist' perhaps has to do with mistaking the women's movement as being anti-men. Yet by having marked their presence in the Philippine and Asia-Pacific art scene they are inevitably making a statement. It is with awe that some observers note the amount of art produced by women in the Philippines, from the more mainstream images and forms to peripheral artistic activity. And the debate rages on.

Although the art scene is lively, particularly in Manila, it is also in a fix. To a certain extent this is due to the nature of relationships among a rather small community of artists and art mediators. It is a small club in which people know each other by name and, in the crowded atmosphere of little patronage and plenty of talent, controversies surge with heated passion. To assume that the debate is sheer cabalism denies the merits of struggling to produce art in an awkward, sometimes hostile, environment for artists. Lack of economic support is often a cause for rivalry. But essentially it is the dominant male orthodoxy in the Philippine art scene that kept most women out of the way until recently.

If artists comprise a tiny fragment of the Philippine population, fewer still happen to be women. Ironically, there are more women entering art schools and becoming art teachers than there are men. Female gallery owners and managers also outnumber their male counterparts, while only a handful more male than female art curators are working in museums.

Conventional and traditional shared attitudes continue to privilege male artists. The situation can be likened to an extended family in which women are predisposed to serve men. In the Philippines, women often do not have time to pursue art careers because they are expected to be the main family care-provider. The inability of most women to make a living out of their art further discourages them from getting involved in producing art.[2]

As if this were not enough to make the faint-hearted grow even weaker, the issue of what it means to be Filipina concerns contemporary women artists considerably. Being Filipina (contrary to the male designation Filipino) involves negotiating a number of trite assumptions made by others of her character. The images created from these assumptions sometimes reflect the stereotypes she has learned to construe, but also often belie struggles of an inner self seeking to breach the stereotypes.

The image of the Filipina perpetuated in the hordes of local and

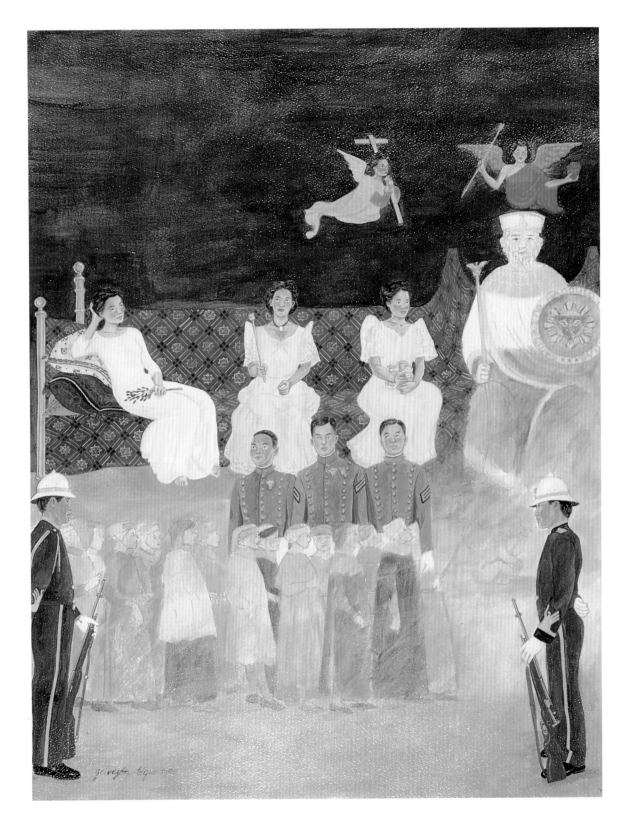

above and opposite: **LANI MAESTRO, a book thick of ocean, 1993,** (installation detail) bound book, linen cloth cover, titles stamped in silver, duo-tone reproduction, 550 pages, oak table. Photograph Lincoln Mulcahy.

national beauty contests, in images of current film stars, and glorified in advertisements, helps to create a particular 'look' that is brandished as elucidating the virtues of an identity. This categorical, if somewhat inappropriate, description intimates a sinister and less than flattering association with sex tourism, mail-order bride catalogues, and other forms of prostitution, sexual or otherwise.

In speculating briefly, if imprecisely, about some of the issues that inform an attempt to define the Filipina, Filipina artists too are only beginning to deal with these issues. There is a growing acceptance that the limitations brought on by their gender and the resources available to them form their particular cultural identity. Central to the analytical development in cultural studies is the way the work produced from the marginal position of women, as Janet Wolf observes, 'differs in important ways from the work of men'.[3]

Being female in a feudal, patriarchal and quasi-modern society is a difficult existence. Few artworks come to mind that directly criticise the present disposition. Julie Lluch's series of figurative genre sculptures, begun in the late 1980s, captured women's frustrations with domestic, middle-class life. Imelda Cajipe-Endaya has also engaged with this theme, using the ironing board in her installation work as an icon of drudgery. In a context in which verbal criticisms are often deemed offensive, the Filipina can begin to confront these issues frankly through artistic expression.

In recent years, through the initiative of women artists, steps have been taken to redress the imbalance in the representation of art by women. Gallery-owner Norma Liongoren is sympathetic to the cause, and since 1989 has held all-women group shows annually. On the other hand, the Kasibulan Women Artists Organization has an active exhibition program, as well as other art projects involving its community or women in other arts fields. Not to be outdone, the tight group of gallery owners known as the Committee of Independent Commercial Galleries organised a thematic exhibition late last year on the Filipina's identity and how she views herself.

Although these are laudable activities, it is sometimes too easy to fall into the habit of accepting tokenism rather than genuine advocacy. The road to an alternative criteria by which women can evaluate their work is an overgrown path that few take. Women's art is difficult to judge because for a long time access to the canons and written history of art was reserved for men. A future research area should seek to formulate a new art history framework that integrates Philippine art, South-East Asian art, or even the relatively new concept of island South-East Asian art[4] from a feminist perspective.

This article focuses on eleven Filipina artists who have gained a measure of recognition for their work. The most interesting aspect of their art is its sense of intimacy and responsibility. Through their work they

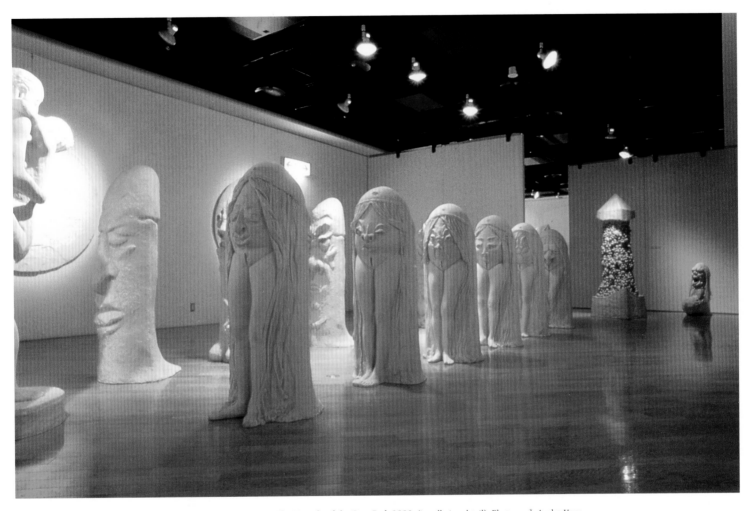

AGNES ARELLANO, Myths of Creation and Destruction Part II: The Temple of the Sun God, 1990, (installation detail). Photograph Ayako Koga.

opposite page: AGNES ARELLANO, Through Her, With Her, In Her, 1991, (installation) Metropolitan Museum of Manila. Photograph M.G. Chaves.

affirm the urgency and compulsion of essential creative imagination rather than propounding a treatise of what they are not. The essential reading of the images is their lived experience and the process of becoming an artist, despite the lowly status sometimes accorded to them. It is having the will of imagination to disclose that which exists.

Among the expatriate artists, Nena Saguil is considered one of the last Philippine modernist painters. She left behind more than 300 artworks in various media when she died in Paris in February 1994. In her lifetime, she received artists' grants, exhibited her works in the Philippines, Europe and North America, with her works represented in a number of corporate and private collections. She is also represented in the Foundation National d'Art Graphique et Plastique and the Musée Centre National d'Art Contemporain.

Saguil's journey in search for the right artistic space brought her to Paris in 1954 as an art scholar at the Palais du Fountainebleau. After two years she decided to take up permanent residence there, living on her own in a small apartment-studio near the Left Bank. She committed her life to work, preferring to remain unmarried and to lead a simple lifestyle which enabled her prolific artistic production. Far from being the romantic heroine of fantasy art biographies, Saguil was a professional artist who took the responsibility of representing herself among art dealers and buyers.

The time in Paris was a period of experimentation with techniques and materials, and during this time she also pursued her scholarly interests in philosophy and art history. Before going abroad, Saguil was identified with the Neo-Realists, strongly influenced by the Impressionist and Cubist styles of older contemporaries Vicente Manansala and H.R. Ocampo. Her distinctive 'cosmic landscapes' emerged during the 1960s. These abstract forms, which appear to be suspended in infinite space, were marked by globular shapes textured with curvilinear lines, minute circular shapes or pointillist strokes. Her work recalls the cosmos, but for Saguil it represents more the universe of her spirituality.

Another expatriate artist is Ofelia Gelvezon-Tequi, who until recently was residing in Hong Kong with her husband and three children. She is now back in Paris where they have lived previously. Tequi is a well-known printmaker and painter, whose work refers to the mystical as well as political and social character of human existence. Her images are drawn from her observations and personal history, affirming her belief in the timeless universality of human values and aspirations. When the series based on Ambrogio Lorenzetti's *Allegories of Justice, of Good Government, of Bad Government* was shown in Hong Kong, Tequi knew that it aroused interest not because of the esoteric Filipino reference and visual puns, but because of a common, simple human quest for happiness within society.

The artist, who received a diploma in painting from the Accademia di Belli Arti in Rome and attended special studies in graphic arts at the Pratt Institute in New York, does not believe in gender categories. She finds terms like 'one-person shows' too awkward. Her artworks and statements are specific and individual because she believes they are a product of the personal conditions of her having been born and educated as a Filipino, being a woman, and working outside the Philippines.

Although she is able to exhibit her works annually (mostly in Manila), Tequi's family remains a priority. By the way in which she recounts the pleasure of touching textured paper or primed canvas, the smell of etching inks or linseed oil, or the sound of a scraper on copper or bristles on linen, one surmises that the time left for her artwork is precious. The process of creating absorbs her just as much as producing a visual language.

Lani Maestro agrees that only aspects of her work reflect the conditions of the category of the Filipino woman artist working outside the Philippines. Currently living and working in Montreal, Canada, she says that she is 'informed by [her] own history and situates [her] condition by locating the personal (autobiographical) within the social'. Citing another artist, Dorit Cypis, who asserts that 'we can't keep treating our bodies like the third world', Maestro reflects this rethinking of our relationship to our bodies and our emotions as a positive way of addressing and analysing how colonialism has been internalised.

Although not a member of any organised group, Maestro's art practice comes from and is informed by a certain feminist perspective. She is fortunate to be part of a gallery system in North America which is supportive of her work. Apart from exhibitions, she is involved in publishing and editing an artists' journal, *Harbour* magazine, writing and publishing her works in another magazine, *Parallelogramme*, as well as in catalogues and books. She also teaches part-time, and is co-founder of Galerie Burning and Burning Books in Montreal.

Despite the exodus abroad of many Filipina artists and the hazards of limited opportunities in the Philippines itself, a number of artists who have stayed on are making a name for themselves in the Philippine artworld. One of these is the Manila-based sculptor Agnes Arellano, who believes that art can transcend gender and that categorisation tends to increase marginalisation even more. She would rather that her images of the 'Goddess' reveal the not very politically correct theme of the universal. Best known for her surrealist and expressionist work in cast and directly modelled plaster, bronze and cold-cast marble, Arellano's work tends to stress the integration of individual elements into a totality, referring to them as 'inscapes'. The artist has a general preference for group shows, believing that art should be interactive, if not collaborative, in nature.

KAREN FLORES, Bantay Salakay, 1993, oil, 91.44 x 121.92 cm, courtesy the artist.

According to Arellano, the drive to make art comes from the urgency of 'scratching a spiritual itch'. The process involves a form of ritual: two months are spent reading esoteric books on a subject that concerns her, researching and creating a working bibliography. As soon as she feels 'metaphorically pregnant' with ideas, she translates this quickly into plaster by direct moulding. This intuitive method contrasts with her rational and intellectual planning included in the process. Soon after a model is made, a final cast is done using polymer resin.

Arellano has been identified with the Pinaglabanan Galleries in San Juan, Metro Manila, which she owned and managed until it closed in the latter part of the 1980s. Pinaglabanan's esteem rose at the time when there were hardly any commercial galleries showing stimulating and imaginative exhibitions. It drew critical acclaim for showing works by artists like herself which were deemed far too controversial for mainstream galleries.

Arellano considers herself as a full-time wife and mother (when her daughter is home from boarding school). She is a working partner to her husband when travelling with him, 'eating faxes for breakfast'. Her exhibitions have to be planned every two years because of the time involved in making her art. In between intervening interests, she is currently teaching herself to paint, a sculptor to the core who is wont to model forms by exploiting colours on two-dimensional surfaces.

Susan Fetalvero-Roces also considers herself a full-time wife and mother. Her supportive husband has always encouraged her artistic pursuits. Besides learning pottery and etching on copperplate, she has explored a wide range of media such as oils, pastels and charcoal. Roces is renowned for her abstract paintings which integrate her training in Chinese brushwork with her own mixture of gouache, water-colour and ink. After having a child, she began to feel pressures on her work schedule. Roces found a compromise by putting in as much time as possible in between her child's waking hours.

Apart from preparing for frequent group and solo exhibitions, the artist is also involved in organisations such as the Kasibulan and the Art Association of the Philippines (AAP). The work includes exhibition organisation, planning talks, arranging art competitions and preparing for participation in international shows. Currently the Vice-President of the AAP, Roces is undaunted by either the amount of work expected of her or the fact that she works with mostly male artists. She considers her participation in this context useful in making male artists aware of the value of women's contribution in widening artistic space and in engaging in the struggle to produce collaborative projects.

Like Roces, Brenda Fajardo and Imelda Cajipe-Endaya are concerned with organising artists to form a common bond. Both are anxious that women artists achieve a supportive community in a profession in which women are still in a minority. They helped found the Kasibulan,

which is unique in South-East Asia as the only women artists' group in the region. Fajardo values the increased gender consciousness that encourages women to describe themselves as 'women artists' – a label she trusts will be discarded as women develop confidence in their artistic abilities.

Fajardo is acclaimed for her drawings of indigenised tarot cards that draw on Philippine events and myths. Although she cites as her main difficulty the lack of time due to other tasks and projects, the benefits of art-making give her the opportunity to reflect on things around her and, in the process, help synthesise her life. Being single, she is bound by the responsibility of caring for her elderly parents, a role she has assumed as part of the Filipino culture. Nevertheless, these challenges do not limit Fajardo from being a full-time art educator as Art Studies Professor at the University of the Philippines and an advocate of children's art.

Fajardo's growth as an artist parallels Endaya's, both having been first acclaimed for printmaking and since having moved on. They were among only three women of nine Filipinos selected for the first Asia-Pacific Triennial of Contemporary Art in Queensland in 1993. Endaya, who is married, now has more time for her work since her children have grown up. Her latest works, constructed from discarded objects mounted on canvas and richly painted with oil, make multilevelled statements on indigenous culture, gender issues, and against injustice.

Aside from organising women artists and making art, Endaya has published her researches and writing on Philippine contemporary and folk art. She accepts that the gallery system will always be difficult for artists who are constrained by lack of opportunity and unable to produce enough works – usually women, for whom art production is a struggle. By exhibiting together while involving sympathetic male artists, Endaya suggests that an interaction project such as a mural could be one solution.

As more women become politicised due to their personal experience, self-expression through art becomes a form of catharsis which transforms their consciousness into larger social concerns. Anna Fer's diaries became her source of inspiration when she had her first solo exhibition in 1979. After her marriage ended in 1977, she turned to art to help her sift through the experience. The result was some forty works that dealt with subjects such as the essential woman, inner landscapes, and loneliness. Fer concludes that the female visual language is a potent form through which to express affinity with the world and other women.

During the late 1970s and 1980s, Fer became involved in the groundroots campaign against then president Ferdinand Marcos's unconstitutional rule. She found herself immersed in political propaganda, making murals for marches and drawings for leaflets. Fer

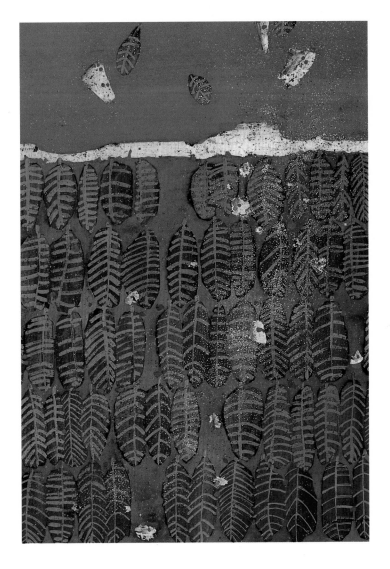

SUSAN FETALVERO-ROCES, **Deliverance, 1993,** ink and gouache with gold leaf on paper, 54 x 38.5 cm, courtesy the artist.

top: **LYDIA INGLE, Untitled,** oil on canvas, courtesy the artist.
above: **LYDIA INGLE, Chismis (Gossip), 1993,** oil on canvas.

regards this phase in her life as a process of self-refinement, preparing her to be part of a larger world beyond herself. She has been illustrating books and is currently making a manual for gender sensitivity in the corporate world. One of her most outstanding illustrations is based on the visual life of the island of Palawan, in collaboration with French anthropologist Nicole Revel.

Another artist involved in advocacy is Lydia Ingle, who lives in Davao City in the island of Mindanao. She runs a family endowment to promote nature and wildlife conservation in farm zones. Working on her farm takes up most of Ingle's time. She does not believe she can earn a living from being a full-time artist. Ingle travelled and lived in Europe for most of her life, obtaining art training in Madrid, Paris and London. She worked for ten years in the foreign service of the Philippine Embassy in London, finally settling down in Davao in 1975 with her three children. Ingle is not only a gifted painter: she is also an award-winning writer (for her biography on 1966 National Artist Victorio Edades) and an accomplished musician.

The images Ingle produces are often of people set in a paradisiacal place, an allusion to her concern for Davao's depleting forests. The figures within her compositions are slightly askew, signifying a foreboding sense of doom.

A similar atmosphere of desolation may be found in Karen Flores's works, although her subjects deal more directly with the marginalisation of women. The idiom she uses comments on society as a whole and not only on her condition as a woman artist. Now that she has a child with her husband, the artist Mark Justiniani, Flores has discovered more pleasure in painting as a mother and still considers herself a full-time artist. Finding the time and being able to afford the expensive art materials are her main concern. Despite her intention to make a living from art, she is critical of the gallery system and is constantly in search of alternatives.

Flores has an impressive track record of group exhibitions and has worked as a writer and artist for publications. As a founding and former member of Salingpusa, she contributed to group advocacy and commissioned projects of mainly large-scale paintings and murals. After just having had her first solo exhibition in November of last year, Flores participated in the ARX Festival in Perth, Western Australia, this February. She hopes to continue her technical collaboration with her husband and other artist-friends, and is disinclined to subscribe to the growing individualism among her peers.

Joy Mallari, on the other hand, experienced a different form of collaboration when she joined Philippine Animation Inc. Mallari decided to go into commercial art due to financial pressures and the need to rethink her direction as an artist, a decision she does not regret, as it has opened up another artworld to her in which the spirit of co-operation

is both necessary and heartfelt. Her commercial art activity has subsidised her other work: she has now gone back to oil painting after working mostly with watercolours.

Mallari is not a member of a women artist's group because she believes it makes women more peripheral. She sees the struggle not just among women, but in the basic need for survival in the Philippines. Her works record the faces of those she encounters on the jeepney ride home to Antipolo, a distant suburb in Metro Manila. She claims her paintings are more concerned with the Filipino soul, starting with her desire for self-expression as a means 'to relate my life to my work'. Mallari became a single parent to her adoptive sister soon after her mother died. Mallari, who is in her early twenties, finds juggling work and time constraints difficult, but sees being more disciplined as a way of coping. She is soon going into painting full-time while preparing for her first solo exhibition this year.

There is a pleasant resonance among the stories shared by these Filipina women artists: it is the voice of boundless energy and tenacity to achieve a measure of success on their own terms. If curators, art dealers and critics are serious about giving support to women artists, they should do away with perfunctory gestures and instead allow them wider access to opportunities.

Special galleries devoted to women or even thematic exhibitions devoted to women's issues are not ideal solutions, looking more like patchwork quilts of palliative remedies. Conditions must be created through active lobbying for real and equal opportunities for artists that will enable them to make art on a full-time basis. Issues surrounding hybrid identities, gender consciousness and multicultural policies are immediate and should not subscribe to the gloss of political correctness. We have only to look into the sincerity and the imagination of some of the women artists who have 'made it'. At the heart of the matter is the courage, audacity and sense of purpose exhibited by many Filipina artists, as they push the boundaries and edges further so that the fringe looks a little more even and auspicious.

1 'Hybrid Identities', *Art in America*, September 1994, p. 51.
2 I am indebted to arguments made by Linda Nochlin, 'Why have there been no great women artists?', *Art and Sexual Politics,* Thomas B. Hess and Elizabeth C. Baker (eds), Collier-Macmillan Ltd, London, 1973; and Janet Wolf, *The Social Production of Art,* Macmillan Ltd, London, 1981.
3 Wolf, p. 43.
4 Paul Michael Taylor in his introduction to the book, *Art of Island Southeast Asia,* Metropolitan Museum of Art, New York, 1994, provided a definition to the area comprising ('minimally') the modern nations of the Philippines, Indonesia (except Irian Jaya), Brunei, and the eastern part of Malaysia (Sarawak and Sabah) which implies a different cultural context than the more political grouping of the ASEAN (Association of South East Asian Nations) region.

Ana P. Labrador is an independent curator, art critic and consultant. She is currently on leave from teaching at the Department of Art Studies, University of the Philippines, Diliman, to pursue a PhD in Social Anthropology at the University of Cambridge, England.

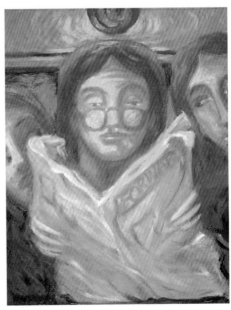

top: **JOY MALLARI, Lagas-Gas, 1994,** oil on canvas, 85.8 x 50.2 cm.

above: **JOY MALLARI, Biyahe III, 1994,** oil on canvas, 61.3 x 46 cm, Boston Gallery.

kartika affandi-köberl

undermining the order of the javanese universe

astri wright

Kartika Affandi-Köberl, born in 1934 in Java, is the daughter of Affandi (who, along with Sudjojono and Hendra, is considered the father of modern Indonesian painting) and of Maryati, who was also an artist.[1] Kartika is one of few contemporary Indonesian artists who grew up with paint, canvas and modern art as central parts of their lives, not merely as a fashionable 'modern' appendage in an emerging, urban middle-class lifestyle.[2] Like Affandi (1907?–90), Kartika never received formal art instruction.[3] From the age of seven, she was instructed by Affandi in how to paint with fingers and tubes directly on the canvas. Any mixing of colours is done on her hands and wrists. Kartika has no permanent studio; like Affandi, she prefers to paint outside in the village environment where she interacts directly with her subjects and on-lookers. This contrasts with most contemporary Indonesian painters, who work in their studios from mind-images, memory, photographs or sketches.

In a modern art world born in the 1930s, in which men are still the predominant actors, Kartika is one of a small group of women who from the mid-1980s have succeeded in exhibiting their work on a regular basis and in gaining limited critical recognition.[4] Even in this context, Kartika's art emerges as unique, ranging as it does from conventional to subversive.

In a culture where the individual self rarely is put to the fore, Kartika has made the self-portrait one

KARTIKA, **Rebirth, 1981,** oil on canvas, 132 x 133 cm, collection the artist. Photograph Astri Wright.

below: **KARTIKA, Oxcart, 1988**, oil on canvas, collection the artist. Photograph Astri Wright.

opposite page: **KARTIKA, Venice, 1984**, oil on canvas, collection the artist. Photograph Astri Wright.

of her main themes. In a society where emotion is suppressed, both publically and privately, Kartika fills her canvases with intense feeling. In a culture where genitals are considered taboo in representation, Kartika has painted her own nudity graphically and without the prescribed, distancing sweetness, never depicting the body as an object of pleasure, whether that of others or her own. Going against the Javanese insistence that harmony and beauty of both material and spiritual kinds be normative for all forms of creative expression, Kartika creates turbulent and disturbing images of real life, at times turning traditional iconographies on their head.

I divide Kartika's work into two groups: one, her most personal and psychologically probing art, which she occasionally refuses to sell, and the other, her public 'bread-line' work that sells well. The latter canvases combine qualities of the pre-independence 'Beautiful Indonesia' school of painting with Kartika's personal vision of harmony. In these, she plays with lyrical images and nostalgia-provoking cultural icons, both from Indonesia and abroad (Balinese temples, Rangda the witch, a Javanese bird market, an Austrian village church in snow), painted in a style which, despite the reservations of western art critics, is highly regarded in Indonesia. These paintings are infused with the sensuous splendour and otherness of the realm of the touristic. It is Kartika's energetic handling of the paint in delicate, well-balanced compositions which makes some of these works superior to most Indonesian paintings with similar themes.

The second and, from a conventional Euro-American art-historical perspective, more significant work – as well as that which most clearly sets Kartika apart from the majority of Indonesian painters – is her portraiture.[5] Kartika's portraits achieve a psychological depth rarely seen in an artworld in which the individual is still largely depicted as a character-type or as representative of the larger community.[6] Kartika paints people in a way that gives them a tangible psychological dimension, never flattering her subjects by painting them more beautiful or less marked by life than she sees them.

Not surprisingly given their close bond, Kartika has painted numerous penetrating portraits of her father, right through the last years of debilitating illness at the end of his life. Another provocative portrait, *Hindu Priest*, shows an old man, close up, as he walks on a beach. His face is preoccupied, intense – a face that might have been taken from an Ingmar Bergman movie. There is nothing here of the glamour, romance or mystical aura that so often characterises images from Bali such as in O.H. Supono's *Balinese Priest*.

Following in the populist footsteps of Affandi, Kartika also has a long history of painting rural and/or dispossessed people such as fishermen, farmers, workers and beggars. Since these individuals pose while interacting with her and exchanging life histories as she paints,

these must be considered portraits. Although narrative, her paintings when viewed close up dissolve into strong, abstract statements in energetically applied impasto oils. Kartika's work ranges from the sweet and idyllic to an expressive realism that can be harsh. The latter is evident in her paintings of beggars, handicapped people and suffering animals and in her uncompromising depiction of the progress of old age, whether painting a stranger, her father, or herself.

As a western researcher of contemporary Indonesian art, I find Kartika's self-portraits the most involving of all. Kartika is unusually open about her past, presenting her personal history as intricately connected with her self-image, both in her own psyche and on the painted canvas. Thus it becomes relevant to explore the connections between biography and the process by which emotions become encoded in paint: such an approach posits art and life as two inseparable strands in the single narrative of how physical markings (on a body, on a canvas) change over time. What follows is a sketch of the dramatic and unconventional life-story Kartika tells, to Indonesian women's magazines, the daily press, national television, friends and foreigners.[7] She tells her story as background to two of her most symbolic and autobiographical self-portraits. To outsiders, her story provides a glimpse into what married life can be like for a contemporary Indonesian woman. It is also an example of the issue which has been at the top of the agenda of the Indonesian women's movement since the 1930s, still unfulfilled: the drive to get polygamy legally abolished.[8]

Kartika was engaged to a young Javanese artist, Sapto, at the age of fourteen; at seventeen, they were married. From a petty-nobility family in Central Java, Sapto had married into the most important artist-family in Indonesia, and he quickly developed his talent for public relations and art-entrepreneurship. He allowed the strikingly beautiful Kartika to model fully dressed for groups of painters in Yogya, but he discouraged her from wasting money on art materials for herself.

From the beginning of their marriage, Sapto was alternately unfaithful and repentant. Kartika tells how she spiralled in a cycle of anger, hurt and depression, yet the children kept coming. Up against Javanese social pressures which sanction polygamy (formal and informal) and censor divorce, she felt powerless, caught. A self-portrait from 1966 reveals her tired and drawn, her pallor green and a bitter line around her mouth. The colour choices and the vigour with which she treats the paint underline her state of mind.

While still in hospital after the birth of their eighth and last child, Kartika found that Sapto had taken a second wife. Personal ethics and emotions aside, this was illegal according to Islamic law, which demands that secondary wives can only be taken with the permission of the first wife and only if the husband can guarantee that he can share his resources and time equally between them.

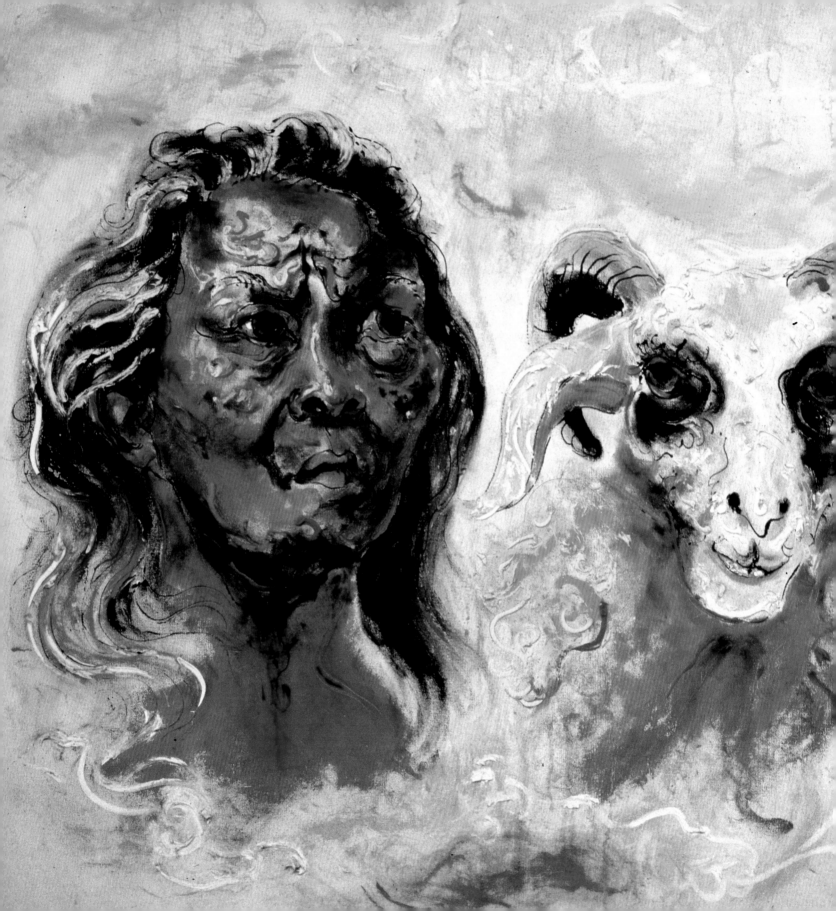

Undermining the Order of the Javanese Universe

*The self-portraits of
Kartika Affandi-Köberl*

Astri Wright

KARTIKA, **Self-portrait with Goat, 1988,** oil on canvas,
120 x 100 cm, collection the artist. Photograph Astri Wright.

Kartika decided to take matters into her own hands but Sapto would not agree to a divorce. Most likely, his position as Affandi's son-in-law was too important to him. I believe there were also other, deeply ingrained Javanese symbols of male and female power at play here. At this time, Sapto was already beginning to cast himself in the idiom of a 'small king' – an extension of the 'Bapak'ism' (a kind of Big Father'ism) which characterises male behaviour in Java. This proclivity was eminently clear in Sapto's discourse by the time I interviewed him in 1988: he received me in the living room adjacent to a hall he had built as a replica of a Central Javanese sultan's throne room, complete with carved and gilded thrones for himself and his wife.

Vis-à-vis a foreign art researcher, Sapto adopted a populist pose as patron to poor Javanese craftsmen and working people, claiming that he had created his home as a 'palace of art for the people' where, he said, 'anyone, even *becak* (rickshaw) drivers, can come in – provided they dress and behave with the proper respect'. (Needless to say, none had been observed entering his ostentatious and well-guarded entrance portal.) On the walls of his home hung photographs of himself and his model-wife posing with the Indonesian and the international royal and economic elite. Interspersed with this regal and superstar paraphernalia were Sapto's own paintings, reliefs and sculptures, as well as Indonesian antiques, tribal- and folk-arts – all for sale at the appropriate price.

Given his royal airs and resistance to giving up his stake in Kartika – a passionate, beautiful, independent and well-connected woman who had borne him eight children – I would argue that Sapto on some level experienced his ability to keep Kartika bound to him as proof of his physical–spiritual potency, in an idiom known from eighteenth- and nineteenth-century Central Javanese court culture.[9]

Discussing the lore surrounding the spiritually powerful thirteenth-century Javanese queen Ken Dedes (sculpted posthumously as Prajna-Parámita, Buddhist Goddess of Transcendental Wisdom) and a seventeenth-century Javanese princess, Carey and Houben write: 'Both of these women were so "hot" in the magical sense, that flames issued forth from their wombs, and only men of unusual potency were able to possess them.' Such women, against the tradition of aristocratic Javanese women who on occasion dressed in men's clothing and led soldiers into battle, were seen as *ardhánárishvari* (mistress or queen who is half male), the very pick of women. Even the poorest man who could make her his own would become a supreme ruler'.[10]

The image of women with flaming wombs, at times cross-dressing as men, is potent also from the perspective of Kartika's and other Indonesian female artists' life and work. It seems likely that someone cultivating a 'traditionalist' image of the 'man of prowess' would desire to have attached to him powerful women who would increase his own power and status.

However on target such speculation may be, Sapto's behaviour not only kept Kartika from self-respect and contentment with her role as wife and mother but also from developing her artistic talent. By not agreeing to a divorce, Sapto also caused her public humiliation and personal isolation. She was forced to challenge the practice if not the letter of Islamic marriage law and laws pertaining to women's rights both within and after the termination of marriage. It took Kartika four full years of bi-weekly appearances in Islamic court to achieve her independence. The divorce was finally granted in 1974. In the process, Kartika was publicly criticised as immoral and ostracised by friends and social contacts. She withdrew to the fold of her family – her father, mother, children and grandchildren.

The second beginning in Kartika's artist career occurred around 1980, when she studied painting restoration in Austria to enable her to repair Affandi's deteriorating paintings. Here, solitude and reflection paved the way for her most unique self-portraits.

The Moment of Beginning and *Rebirth* are the strongest statements found in modern Indonesian art concerning a woman's painful search for identity and, by extension, every human being's reaching for liberation from culturally imposed emotional and behavioural constraints. Such works are unique in that they are autobiographical, disturbing, and by some standards, ugly – qualities not sanctioned within the dominant Indonesian aesthetic.

The Beginning is composed in such a way that traditional iconographic rules are turned upside down: the head – the body part given the highest value in Javanese culture – is located at the lowest point on the diagonal of the body, on the left side of the canvas, traditionally the side of the feminine, of lower metaphysical value. Bleeding female genitalia dominate the right, upper part of the canvas. This is where the head should have been, the right side representing the masculine side of the universe, that of spiritual power and enlightenment. Finally, the sense of falling which so characterises this work violates a deeply ingrained and consciously exercised Javanese cultural urge towards balanced and upright reserve. Similar iconographic revolutions are effected in *Rebirth*, where the head of an older woman being born adds another level of contradiction.

Not seeking to idealise her own facial features, Kartika has given us an image which is both instantly recognisable as her as well as representative of every woman. The woman's tearing off mask after mask in *The Beginning* until she reaches the bare bones of her skeleton is a powerful way of suggesting roles she was socialised to play, identities she was forced to assume, which she can no longer bear.[11]

Kartika's lack of reticence about her body is unusual in Java. In this respect, she is also at odds with a culture in which the body, sexuality, nakedness, left-handedness, etcetera, are areas of life that are considered

necessary to suppress. Her depiction of the female body provides a sharp contrast to the immensely popular plastic Barbie-doll pinups of Indonesia's most celebrated salon-painter, Basuki Abdullah: the nudity in his works is so unreal as to hardly bother anyone. Kartika, on the other hand, paints the muscle-heaving and flesh-tearing of birthing labour in a manner which eschews reference neither to the natural functions of the body nor to their metaphorical power to represent psychological processes.

Kartika can be seen as a contemporary descendant of nineteenth-century Javanese women of 'flaming womb' and militant action in male dress. Like other Indonesian women who have awoken to their systemic marginalisation, Kartika manipulates gender and class codes, crossing back and forth at her convenience between male/female and elite/popular signals. At certain times, she exercises the powers allotted her as an *Ibu Besar* (Great Mother, patron) to the full; at other times, she communicates and works with lower status folk as an equal. Person-to-person, she can be surprisingly spontaneous and loud, or intimately confiding, even revealing, in ways considered atypical to either Javanese men or women. When it benefits her, on the other hand, Kartika acts with the authority appropriate to women of her class. When dealing with lower-ranked people, this means taking on the trappings of formal male authority. When dealing with men of her own

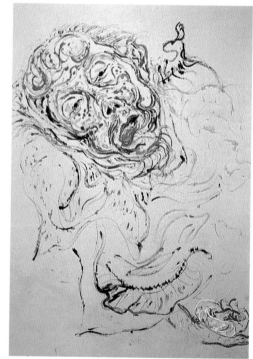

class, or with male Indonesian officials, she plays an appropriate Javanese female role – somewhat deferential, a little flirtatious, though without losing the nuances appropriate to her class and social standing. This stance of authority – coupled with a society-wide respect for Affandi – has in the past allowed her to get away with things other less well-known Indonesians, let alone women, could not have.

Crossing normative boundaries is reflected in Kartika's clothing as well: in a society where mature women are not considered clothed unless they are wearing formal dresses or skirts and blouses with collars and buttons, Kartika often wears pants or kaftans in public: to her own generation, the first is considered 'male' or 'teenage', 'not-yet-a-full-person' clothing, and the latter is considered on a par with wearing a bathrobe. Pants allow her to stride around freely and sit less stiffly, not always having to keep her legs parallel and knees together. Pants also allow her to drive a large jeep and haul timber and bamboo to be used in constructing her home in the forest – distinctly unfeminine behaviour in Java. Details such as these are not merely something a foreigner might note: in a 1977 interview, after being labelled 'too masculine' even by fellow artists in the press, Kartika attributed her so-called masculine behaviour to the fact that after the divorce she had to try to be like a father to her children; in addition, she had been extremely bitter and isolated, and in effect for a while 'hated men'.[12]

The late 1980s saw Kartika finally confident about being in control of her life and art. She is comfortable with her multiple roles as artist, painting restorer, president of the Affandi Foundation, employer, wife, mother, and grandmother. She is economic matriarch of a large family and patron to the people of a small mountain village where she has built her retreat-home. In her discourse, although she professes to not consider herself one, she at times sounds positively 'feminist'. When National Television wanted to do a *Profil Budaya* (Cultural Profile) interview with her for National Kartini Day (celebrated in honour of the first champion for women's education), Kartika answered: 'I am not interested in being interviewed because I am a *woman painter*. I will gladly do an interview as a painter, but why should that be on the *one* day a year which is set aside for women? When do we have a special day set aside for men?' At this last question she burst into her trademark bubbling, screechy laughter which takes some of the sharpness out of such irreverent comments. Kartika's hard-gained independence and determination is evident in a painting entitled *Self-portrait with Goat*.

In conclusion, then, I see Kartika painting her body as both instrument and landscape: as an instrument for birthing – of children, as she did so prolifically, and, more importantly, of her own true self, as a landscape marked by the erosion and upheavals of this birthing process. It is through images of her body that Kartika charts her search for self and reenacts her gradual physical and psychological transformation. In larger terms, I see Kartika creating a link, in her art as in her life, to a mythology of strong Javanese female characters which has all but disappeared in the processes of colonisation and modernisation. At the same time Kartika, in her manipulation of cultural norms in life choices and aesthetic form, is carving out a new model of female self-empowerment in Indonesia.

1 Parts of this essay are taken from a sub-chapter entitled 'Rebirthing a modern woman: Kartika Affandi-Köberl' in my book, *Soul, Spirit and Mountain: Preoccupations of Contemporary Indonesian Painters*, Oxford University Press, Kuala Lumpur, January 1994. The book is based on PhD research conducted in Indonesia between 1987 and 1991.
2 I will refer to the artist as Kartika. In Indonesia people are referred to in public by (one of) their personal name(s), most Indonesians not having the equivalent of family names.
3 Where nothing else is noted, quotes and information are based on personal interviews conducted between November 1987 and March 1991.
4 The Indonesian art world, with galleries, art schools, important female artists and artist groups are discussed at greater length against the background of gender roles and the Indonesian women's movement in Wright, Chapter 6.
5 Euro-American art history has traditionally applauded originality over conformity, the breaking down of old forms/categories over innovation within existing forms/categories, and non-market values in art making over art made with the customer/audience in mind. These are all among the numerous theoretical and methodological questions which need to be reassessed within the context, history and anatomy of modern art originating outside the Euro-American context.
6 See Wright 1994, Chapter 13.
7 Details in the following that did not appear in the mass-media Kartika told quite openly in a lengthy interview taped by Indonesian National Television in November 1988, from which selections were used in the one-hour-long *Profil Budaya*. It should be unnecessary to point out that what is presented here is only one side of the 'truth': it is the perspective that informs the artworks and the life experience under discussion.
8 See Saskia Wieringa, *The Perfumed Nightmare: Some Notes on the Indonesian Women's Movement*, Institute of Social Studies, The Hague, 1985, p. 10.
9 Peter Carey and Vincent Houben, 'Spirited Srikandis and Sly Sumbadras: The social, political and economic role of women at the Central Javanese courts in the 18th and 19th centuries', Locher-Scholten and Niehof (eds), *Indonesian Women in Focus*, Foris Publications, Dordrecht Holland, 1987, pp. 12–42.
10 Ibid., p. 15. For relevant photos, see the famous classical sculpture of Queen Dedes as Prajnaparamita (Goddess of Transcendental Wisdom), c. 1300, East Java, in Jan Fontein, *The Sculpture of Indonesia*, National Gallery, Washington, 1990, p. 161; for Javanese female court dancers in martial display, and King Kertanegara sculpted as Ardhanarisvara (each fourteenth century), see Claire Holt, *Art in Indonesia, Continuities and Change*, Cornell University Press, Ithaca, 1967, pp. 118 and 81, respectively.
11 An alternate reading suggested to me would be to see the woman as trying to pull her face back on, to cover her naked, suffering core. In either case the terror and pain are at the centre of the work but the woman's efforts would be opposite. Interestingly, this reading was suggested to me by a South Asian woman who might have been strongly socialised to hide exactly those things that Kartika, according to her own life story and the context of her other self-portraits, clearly wants to reveal – an example of viewer feedback which underscores the shocking quality of this painting to an Asian sensibility.
12 Putu Wijaya, 'Wanita Macam Kuda', *TEMPO*, 14 May 1977, p. 26.

Dr Astri Wright teaches in the Department of History in Art, University of Victoria, B.C., Canada.

a woman's place

the seniwati gallery in bali

astri wright

Art collectors and curators (notably from Japan, Singapore, Australia and America) have become increasingly active in Bali. If it is only within the last five years or so that scholars from the various fields that research art have acknowledged that neither Europe nor North America, let alone New York, own the idea of 'modern' or 'modernism' and that alternate possibilities for culturally located 'modernisms' exist, at the same time another case of marginalisation has become evident: where, in this process of inscripting twentieth-century chapters of Asian art history, are the women artists?

Although from certain perspectives Ubud in South-Central Bali appears to be taking on the identity of a 'Kuta North', it is still the centre of the contemporary visual arts in Bali. And, within Indonesia, Bali is the most dynamic arena for art making, artistic commerce and local, national and international artistic exchange. Hence it is not surprising that it was here the first gallery for women artists in Indonesia, the Seniwati Gallery of Art by Women, was founded in December 1991. As the first gallery of its kind in Asia, it provides a much needed institutional framework for Balinese and non-Balinese women artists living and working in Bali. In Indonesia women artists began to gain access to exhibition venues and the attention of collectors, patrons and critics in Java only in the mid to late 1980s, and the Seniwati Gallery provides essential support for some of these women artists and, just as

GUSTI AYU SUARTINI, **Dreaming, 1993,** acrylic on canvas, 38.5 x 57.5 cm, Seniwati Gallery. Photograph Astri Wright.

NI PUTU ANI, **The Shrine in the Ricefields, 1994,** ink and watercolour on paper, 43 x 43.5 cm, collection Seniwati Gallery.

important, offers an inspirational model for women throughout Asia.

Until 1992, when Seniwati began their activities in earnest, the best-known examples of traditional and modern Balinese artists, to Indonesian audiences and beyond, were all men. In 1989–90 I was able to find only one modern woman artist represented in any of the major Balinese galleries; since then, a shift has taken place and a few are now represented in mainstream galleries.

To investigate what distinguished the Seniwati Gallery from the mainstream galleries in Bali, I spent six days talking with the director, staff and some of the artists, gaining an introductory impression of the gallery's mandate, activities and impact on the art world of Bali and beyond, and on the local community. The high energy and enthusiasm which pulsates through the gallery, the *sanggar* (studio-workshop) and the separate gallery shop fuels the creativity and intensive learning of a handful of young Balinese female staff around the challenge of running all the aspects of a gallery. Mary Northmore, the director and co-founder of Seniwati, says she hopes that in five or ten years time her role will be superfluous as Balinese women will run the many-pronged venture themselves.

Who are the women centred around the Seniwati Gallery? At the end of last year, after only two years running, the Seniwati Gallery represented between forty and fifty women artists. Among these, information was available for about twenty Balinese women from Ubud, Pengestanan, Kamasan, Denpasar and elsewhere; eight women from other parts of Indonesia, many of them now living and working in Bali; and four foreign women, married to Balinese and/or working, full or part-time in Bali.

In this article I will concentrate on the Balinese artists. These women range in age from thirteen to sixty-two; from unmarried young girls to grandmothers; from low to high caste and from rural to urban backgrounds. Some are married to artists who take a competitive attitude towards their wives; others to artists who are supportive; others to non-artists who range from accepting and promoting them to actively, in a few cases even violently, countering their aspirations. The art by these women ranges from neo-traditional Balinese styles and subject matter (landscape, mythology and genre scenes) to modern international media and styles (self-portraits; personal dreams and aspirations).

Mention must first be made of the two senior women artists. Ni Made Suciarmi (b. 1932) and Dewa Biang Raka (b. 1937) are, to my knowledge, the most senior women painters in Bali today. Suciarmi is from Kamasan, a village famous for its traditional Balinese style of painting, best known from the Hall of Justice in nearby Klungkung. Her art carries on the tradition of Kamasan style painting, illustrating themes from the Ramayana and the Mahabharatha epics. Such works are intended to promote mental and spiritual progress in the viewer;

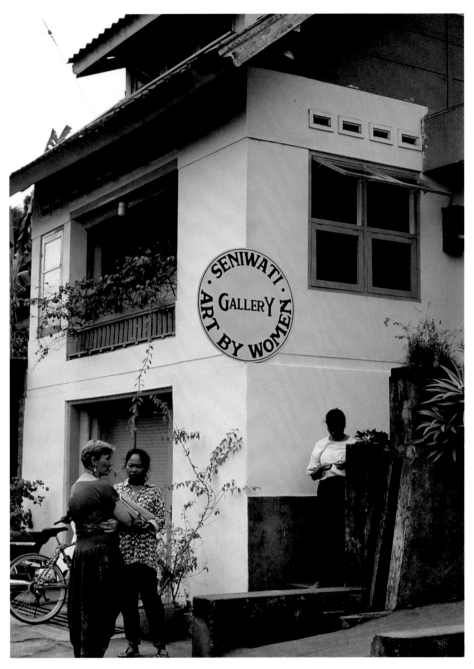

Mary Northmore and gallery assistants in front of Seniwati Gallery. Photograph Astri Wright.

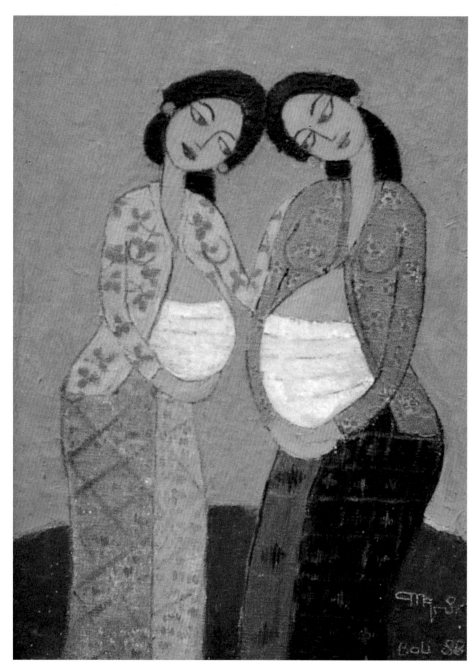

COK ISTRI MAS ASTITI, **Women of the Same History,** 35 x 25 cm, Seniwati Gallery. Photograph Astri Wright.

they are visual lessons in religious philosophy and morality. Suciarmi first learned to paint at the age of six when she helped her uncle on the Dutch renovation of the Hall of Justice in Klungkung, and she is one of the few artists who still uses the traditional materials (colour from natural pigments found in clay, stone, betel and bone; Chinese ink with a bamboo brush; cotton cloth primed with a rice-starch paste and then polished with a sea-shell). Although she has not received the amount of scholarly mention that male artists working in the same tradition have, such as Nyoman Mandra of Kamasan, her contributions have been recognised at the highest levels of Indonesian society.

With her late husband (who was also a painter), Dewa Biang Raka was encouraged in her work by Rudolf Bonnet, who was instrumental in the 1930s and 1950s as fellow artist, teacher, and patron of Balinese art. Dewa Biang admitted to her sense of loneliness during the forty years she persisted in painting before Seniwati created an environment where women artists could get together. Before this, it was hard to be the only woman at artists' meetings or at exhibitions; Balinese gender codes make it difficult for a woman to mix freely in men's company. Today Dewa Biang lives a reclusive life, sought by people interested in her painting and her healing powers. Interestingly, she told me that just as the Seniwati Gallery was being organised she began to feel an imperative to break her seclusion and teach her knowledge of traditional Balinese painting to younger generations. At present, she is teaching schoolgirls in the *sanggar muda* (youth studio) twice a week.

At first glance, Dewa Biang's work appears conventional, but with longer viewing the nearly monochromatic paintings begin to glow, to deepen and come to life in such a way that one swears one saw a peacock feather ruffle in a breeze, a butterfly wing move or a frog's eye dart, conspiratorially, off to the side. An almost magical sense of life beyond what the eye perceives which only mediative viewing can reveal is created, through mental and material techniques that remain the artist's secret.

Moving from the senior women artists to the youngest member of Seniwati, Ni Putu Ani (b. 1981) insisted on studying painting with her father when she was eight years old. By the age of ten, she was already painting on canvas, a sign of how quickly her skill developed. Mary Northmore loves to tell how Ani, now thirteen, 'is too young to be a member of this gallery, but she insists, so who are we to stop her?' When I visited the gallery last July, Ani had already sold six paintings through the gallery and her work is as good as most that is sold in the painting workshops throughout Ubud.

Between these extremes in age we find a fascinating range of women whose art, experience and education vary a great deal. But they all have in common the fact that, for the first time, they have a place to go where their identity as artists is supported and where common problems and challenges can be discussed with others in similar situations. Finally, but not the least important, they have in Seniwati a place where the world comes to see their work and where their collectors – mostly foreign and mostly female, up to now – can find them, whereas previously they were invisible and, to all official purposes, did not exist.

For this brief introduction to one of the most exciting developments in a rapidly changing art world such as Indonesia's, let Gusti Ayu Suartini's (b. 1972) painting *Dreaming* stand as a symbol: besides exhibiting an awareness of the natural environment and her own (or women's) sense of oneness with her surrounding flora and fauna, Suartini's painting gives us humorous, gently sassy, low-key representations of young women just coming into their own sensual and creative powers. May the budding knowledge of their powers carry the women artists of Bali through the next phases of personal and social struggle as they fulfil their talents, to enrich the art world of Bali and beyond.

Astri Wright is Assistant Professor, History in Art, University of Victoria, B.C., Canada. She is the author of Soul, Spirit and Mountain: Preoccupations of Contemporary Indonesian Painters.

lucia hartini

srikandi, marsinah and megawati

martinus dwi marianto

Lucia Hartini's art is a reflection of herself and the way in which she interprets her environment. Indeed, her art is inseparable from socio-political conditions in Indonesia, particularly Yogyakarta, where people still implicitly expect a woman to be able to *masak*, *macak* and *manak* (cook, make herself up and have children).[1] The view that the status of a wife depends upon her husband, and the status of a girl depends upon her father and male siblings still matters according to A.P. Murniati.[2] Jokingly, people often say that the word *wanita* (a woman) derives from the Javanese words *wani* (to dare) and *tata* (to order), which then means that a *wanita* is a non-male being 'who dares to be ordered'. This connotes that a woman is regarded as an obedient subject to male order and admonition.[3] In this respect, up to 1992 Hartini's subjects seemed to reflect these traditional cultural expectations under which women obediently and patiently placed themselves, victims of sexism. In Hartini's recent paintings her subjects are represented in a radically different way – they are spirited, bold and assertive.

As an illustration of the way women are regarded in Indonesia, in a talk on the Indonesian government's plan to introduce a free medical scheme for low income groups starting 1994, the Indonesian Minister of Health, Sujudi, stated that the public should pay more attention to the health of women, particularly those who are pregnant.[4] Furthermore, Sujudi criticised the traditional eating order which places

opposite page: **LUCIA HARTINI, Spying Eyes, 1989**, 150 x 140 cm. Photograph Toto Raharjo.

a mother in fourth place after her husband, her parents-in-law and children.[5] I had once thought that such a notion was just sentimental and unnecessarily finding fault, for at the time I was so caught within the culture that I did not have space to contemplate this. I also naively and with bias thought that such a condition only took place among traditional groups. But I found this wrong; sexism comes out of cultural ignorance and sexist blindness is strong even among intellectuals, although I believe that education lessens sexism.

In Indonesia, women are culturally regarded as 'subordinate' to men, and they live by the rules made by and for men. The gap between the numbers of male and female contemporary artists is very wide. At the Faculty of Fine Art of the Indonesia Institute of Art in Yogyakarta, the oldest art school (founded in 1950 right after Indonesia gained full sovereignty from the Dutch colonial government), there is only one female teacher (a printmaker), no women in the painting department, and few female students.

Hartini is one of the few female artists who makes a living fully from painting in Indonesia. She is *de jure* married to an artist who lives far away in another island and very seldom goes home. Anyway, Hartini is *de facto* a 'single' mother for she feeds her children and does domestic jobs by herself beside painting. That is why Hartini has developed the habit of working at night after her children go to bed.

Hartini was born into a Catholic family in January 1959 in the small village of Mount Sumbing, Central Java, a province that almost a century ago bore the first Indonesian feminist, R.A. Kartini. Hartini received her formal education in art at the High School of Art in Yogyakarta, but she left her study unfinished in 1977 in order to pursue a career as an artist. She spent her childhood living, walking around and playing in a natural, quiet and peaceful environment that is different from the neighbourhood where she now lives in a rented house with her children. To fill her longing for a free and peaceful natural environment, Hartini likes depicting her imaginings of outer space, planets, sea waves and biomorphic rocks. All of these are depicted rhythmically by fine lines.

In repeatedly putting fine lines on canvas, Hartini lets herself be carried away by a personal rhythm, a kind of meditation. Her repeating of lines is like reciting a mantra or litany over and over again, and by so doing one can go into a micro-cosmos or transcendental experience where the gap between the real and unreal becomes blurred. The further she goes the better, according to Hartini. She says: 'I transform anger into colour symbols; for example, an explosion of live-coals red. My art depicts my moods, the happiness and unhappiness I get from my daily life and daydream experiences which are transformed into a never-ending imagined and fantastic world.'[6] This is a kind of psychological catharsis to release stress and boredom as well as fulfilling her aesthetic needs.

opposite page: **LUCIA HARTINI, Srikandi, 1993,** 150 x 150 cm. Photograph Toto Raharjo.

below: Srikandi, a Javanese shadow puppet of the Mahabharata epic, is a brave and bold female figure who characteristically holds her head upward, collection Pudjo Atmosukarto. Photograph Toto Raharjo.

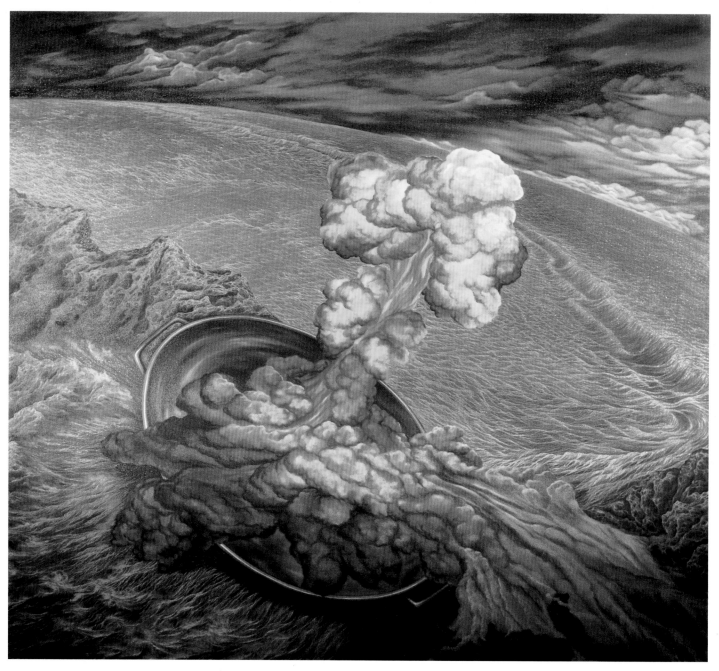

LUCIA HARTINI, Imagination XII, 1987, collection the artist. Photograph Astri Wright.

It is worth noting that from the beginning of her career in the late 1970s until 1993 Hartini often depicted female figures which can be read as reflections of her own situation. However, these figures mostly look powerless, passive, vulnerable, obedient and sweet. The time between 1983 to 1992 was a period when Hartini depicted a sense of terror as she struggled to be herself. Of this period, she says: 'It tells of my obsession with eyes, especially human (spying) eyes, which frighten me very much. They follow me wherever I go and they always want to watch my business.'[7] A good example of the situation can be seen in her painting *Spying Eyes*, 1989, in which she depicts a sleeping female figure who becomes an object of spying, gazing and scrutinising.[8]

Her 1993 work is radically and substantially different. Hartini no longer represents a soft and passive figure; instead, she depicts an authoritative, challenging and strong one. In her painting entitled *Srikandi*, 1993, she projects the daring, strong and powerful character of Srikandi, a daring female knight character of the Javanese shadow theatre. The figure clenches her fists with muscled hands, her head up, with wide-open staring eyes, constituting a strong, challenging gesture against the spying eyes before her.

Because of language barriers and unavailability of material in Yogyakarta, Hartini does not read international art discourses or art politics from the West, with their recent discussions of post-modernism and feminism. It is from her own experience and intuition that she eventually came to the conclusion that women should represent themselves as autonomous subjects having potential which is different but no less capable than that of their male counterparts in this shared world.

It is worth noting that the painting *Srikandi*, with its assertive and muscular-looking figure, prophetically coincides with the emergence of two Indonesian female figures who, in 1993, emerged without precedent into Indonesia's socio-political landscape. One is Marsinah,

a female labourer who on Labour Day (1 May) bravely led her fellow workers to demonstrate for a daily wage rise to AUD$1.50 from a joint Swiss–Indonesian watch-exporting company in East Java where they worked.[9] Marsinah was murdered in a premeditated killing three days afterward.[10] The other is Megawati Sukarnoputri, who was elected in late December 1993 as the leader of the Indonesian Democratic Party, one of two opposition parties, making her the first female leader of a major Indonesian political party. In Indonesia both are now regarded as symbols of the struggle of marginal peoples.[11]

With Hartini's new assertive point of view, her art will be substantially different. I think the potential to express herself fully through her work is great and will be more emotionally and spiritually rewarding for her and the Indonesian art world.

1 See Budi Susanto, 'Pendahuluan Kekuasaan (Pria) Dan Filsafat Peremuan' (Introduction, Power (male) And Female Strategy), in *Citra Wanita dan Kekuasaan (Jawa)*, Penerbit Kanisius, Yogyakarta, 1992, p. 13.
2 A.P. Murniati, 'Perempuan Indonesia Dan Pola Ketergantungan' (Indonesian Women and Dependency Pattern) in ibid., p. 19.
3 See Kris Budiman, 'Subordinasi Perempuan Dalam Bahasa Indonesia' (Subordination of females in Bahasa Indonesia), in ibid., p. 72.
4 'Government plans new free medical scheme for low income groups', *Jakarta Post*, Saturday, 18 December 1993, p. 1.
5 Ibid.
6 Lucia Hartini, Painting Solo Exhibition (catalogue), Bentara Budaya Jakarta, 15–22 April 1992.
7 Interview in July 1993 and see also *Confess and Conceal*, Art Gallery of Western Australia, 1993.
8 See also Dwi Marianto, 'Yogyakartan Surrealism', *ArtLink*, Summer 1993–94, pp. 56–8.
9 'The Tragedy of Marsinah: Industrialisation and workers' rights', *Inside Indonesia*, No. 36, September 1993, p. 12.
10 *Kompas* (Indonesian daily newspaper), 21 October 1993, p. 1.
11 See *Bernas* (Yogyakarta's daily newspaper), 24 December 1993, pp. 1, 11.

Martinus Dwi Marianto is a lecturer at Indonesia Art Institute of Yogyakarta. He is currently completing a PhD at Wollongong University, New South Wales, Australia.

invisible painters

from the revolution to *doi moi*

nora taylor

In Northern Vietnam, during the 1950s, 1960s and 1970s, when artmaking was considered a State enterprise, women artists were part of the artistic workforce. Mirroring their roles in other sectors of society, women were encouraged to take part in artistic production as in the leadership of factories, farm collectives or local politics. As part of the communist government of North Vietnam's program of abandoning the ancient practices of Confucianism or 'feudalism', plans were made for giving equal roles to women and men in labour unions and government offices. As a result, there were equal numbers of men and women enrolled in universities, including the art schools. Prior to 1945, during the French colonial period, education was reserved for an elite class of men, only five per cent of the students enrolled at the Indochinese University were Vietnamese, an even smaller number of those being women. The Indochina School of Fine Arts founded in 1925 counted only five women graduates out of an estimated 150 students in the twenty years of its operation, none of whom are ever cited among the top painters of the time in Vietnamese art history books.[1]

After independence from the French, under the new government, women were given a better chance to study and higher percentages of women enrolled in the art school which reopened under the name Vietnam University of Fine Art. One example of complete reversal from the colonial period

DINH Y NHI, Women, 1995, gouache on paper, 85 x 120 cm.

opposite page: Dinh Y Nhi at her house in Hanoi, 1995.

was the class of 1955 which counted twice as many women as men.[2]

Today the situation is unexpectedly different. While there are still as many women as men attending the art school, fewer women artists manage to get their work exhibited on a regular basis or take part in international exhibitions. Foreign curators and gallery directors who come to Vietnam looking for artists – now that the Vietnamese economy has improved dramatically and the government has opened its doors to the international community – have noticed this. They often ask 'why are there no women artists in Vietnam?'. What they do not realise is that there *are* women artists, only they are not visible. If they knew, they would ask 'why are all the women artists invisible to the public?'. This paper will discuss the situation of women artists in Vietnam very generally and then look at five women from different generations who have managed to attain some visibility, albeit not without difficulty and sacrifice. The main question this paper will address is, why, after almost forty years of State support and equality with men in principle, are women painters in Vietnam still not accepted by their male peers as 'legitimate' artists in actual practice?

In 1994, the first prize in painting at the Annual Hanoi City Art Exhibition was won by Nguyen Thi Mong Bich, a woman painter from Hanoi born in 1933. The painting she submitted to the jury was a watercolour portrait on silk of an old woman reclining in a chair. The woman's features were carefully emphasised, showing every line of her face and the clothes she was wearing; the old brown *Ao Ba Ba* and the wool sweater and black scarf that elderly women of Hanoi wear in the winter. The painting won the prize, but it was not well received by the public.

The Hanoi Art exhibitions are organised by the State-sponsored Artists' Union and in the previous decades it had held a great deal of prestige for artists. These exhibitions were often the only outlets for artists' works, the only exposure artists received, for there were no galleries or exhibition halls to speak of other than those run by the Artists' Union. The painting was seen as 'old fashioned', 'boring' and 'uninteresting' by the more cosmopolitan younger painters who had begun to sell their works to foreigners over the past four years and had opportunities to exhibit their work abroad. The fact that Nguyen Thi Mong Bich won the prize, rather than a younger, more fashionable artist, illustrates the widening gap between what was once considered 'acceptable' or even 'high quality' art under the revolution, and what is considered 'contemporary' and 'modern' under the renovation period, or *Doi Moi*, of today. The Artists' Union exhibition has lost its prestige over the past five years. The prize of one thousand five hundred dollars is no longer considered a valuable sum in comparison with the several thousand dollars that the younger painters are asking for their works in galleries.

opposite page: **NGUYEN THI MONG BICH, Old Woman, 1994,** watercolour on silk, 70 x 50 cm.

top: **NGUYEN THI MONG BICH, Cham Ceramic Village, 1995,** watercolour on silk, 60 x 80 cm.

below: Nguyen Thi Mong Bich at her house in Hanoi, 1995.

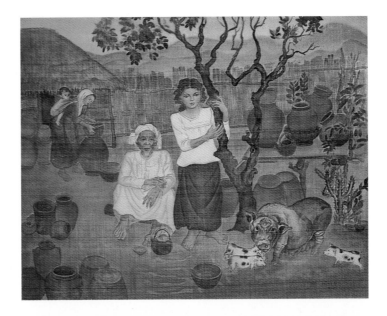

On the other hand, for Mong Bich, the prize meant a great deal. Not so much for the prestige, but rather for the amount of money that it represented. She was able to offer it to her eldest son to help raise her grandson. She had never received such sums of money for her painting before. Her life had not always been easy. Her husband died when her children were young and she was not always able to earn enough money to raise them properly. She had enrolled at the School of Fine Arts in 1960 first and foremost because she had the talent and desire to paint, but also because it offered her flexibility in terms of finding time to raise a family. She could paint at home, or bring her children to school with her while she attended a class in drawing. Her husband had been injured at the battle of Dien Bien Phu in 1954 which prevented him from being able to work. He had to stay at home while Mong Bich went to the art school. At that time, starting in the mid-1950s, the State gave all Northern Vietnamese citizens a food and housing allowance in exchange for work hours. Disabled veterans of the First Indochina War were exempt from work hours and given free rations. Having participated in the resistance movement, Mong Bich was also able to

receive support from the Women's Union and the Artists' Union, both founded in 1957.

When her husband died in 1969, Mong Bich's two sons were still very young. After her husband's death, she enlisted in the movement to the South to help the Viet Minh soldiers support the National Liberation Front which was fighting the American-backed Army of the Republic of Vietnam. She spent three years in the South tending to the needs of the soldiers and entrusted her children to her best friend, also a painter, Le Thi Kim Bach. Kim Bach was born in 1938 and had just returned from the Soviet Union where she studied painting at the University of Kiev. Having no family of her own, Kim Bach took care of Mong Bich's two sons while she painted at home and held the office of Secretary-General of the Artists' Union.

In 1973, Mong Bich came back from the South with paintings, not of the war, but of people. She painted the Cham ethnic minority people when she was in Phan Rang and the Khmers when she was in Song Be and Tay Ninh province. Like many army painters of both Indochina wars, she also sketched soldiers at rest, in their bunkers, cooking, sewing and playing cards. For lack of a camera, artists often accompanied army troops and drew to pass the time or to record soldiers' lives. Vietnamese women were very active during the war, participating in troop movements and taking part in daily survival duties, whether cooking or hiding from the enemy. The equal role given to women and men gave many women a sense of pride in themselves and their nation.

Many accounts have been written about women's roles during the war,[3] although not much has been written about women artists. What can be stated for these artists' case in general, and Mong Bich's in particular, is that being able to draw and paint allowed them simultaneous participation in and liberation from active involvement in the war. Artists could stand to the side and observe. Mong Bich used her drawing skills to document people and in return used the people she observed as models for exercises in portrait-making.

She maintained her interest in painting people long after the war and continues to paint them today. Like the portrait of the old woman, she mostly paints with watercolours on silk. Preferring this medium to oil or acrylic on canvas, she even goes so far as to say that 'silk is softer, more suitable to women'.[4] Her preference for silk is not unique. Many women artists in Vietnam prefer to paint on silk. It is quite common for women who are spouses of painters to use silk painting as their medium so as not to compete with their husbands.[5] The wife will paint in watercolour on silk or mulberry bark paper while the husband paints in oil or acrylic on canvas. The washed-out quality of silk makes the painting appear more subdued and not as bold as oil or acrylic. One painter described this situation as belonging to the realm of Confucian values. 'In traditional Vietnam, women cannot outdo their husbands.

If their husbands are painters then they have to paint smaller and meeker paintings.'[6]

Kim Bach, who studied in the former Soviet Union at the University of Kiev, also mostly paints in watercolour on silk. Like Mong Bich, she has a preference for portraiture and possesses a keen talent for realism. Her portraits are rich in detail and display the sometimes unpleasant features of human physiognomy: wrinkles, moles, hair, scars, etcetera. When I wanted to introduce her work to an American writer, an artist listening to the conversation discouraged me. He looked at the writer and said, 'You don't want to see her work, she's too Russian, not Vietnamese'. I immediately interpreted that as an insult to her and took to her defence. 'But she paints Vietnamese subjects and paints on silk, which is not Russian.' I do not think anything I could have said would have convinced him that Kim Bach's paintings were worth this writer's time. I sensed that the criticism was not so much directed at her 'Russianness', but more at the fact of her being a woman. Women artists had a hard enough time being considered seriously when they felt they had to be careful not to take attention away from male artists; it is harder if their work is not even considered 'Vietnamese'. Perhaps to be a 'Vietnamese' painter means to be a male painter.

Kim Bach also knows that to be a painter means sacrificing some aspect of one's life. For Mong Bich it meant leaving her children behind while she gave her time to her country's struggle against the American army. For Kim Bach it meant never having a family of her own. She neither married nor bore children. 'If I married, maybe I would have never painted. At least I am free to paint when I want and how I want.'[7] This feeling of incompatibility between marriage and painting is due not just to the Confucian ethic of submitting oneself to one's husband, but also to practicality. Married women are traditionally in charge of the household and responsible for most of the domestic chores, giving them little time to paint. Do Thi Ninh, born in 1948, said that she could probably not be a painter if she were married. 'If I were married, I would have the cooking, laundry and cleaning to do. This way, I feel that I have more time to myself. In the morning when I get up, I can paint for a few hours before going to work and in the evening after dinner I can paint as long as I want. My time is not devoted to anyone else but me.'[8] The fact that women feel, or are made to feel, that being a wife and mother come first in their line of social responsibilities is already a deterrent to their desire to be artists. It is also an indication that their work as artists is not taken seriously if it is to be forsaken for domestic duties.

Kim Bach and Do Thi Ninh, like other women who chose to sacrifice marriage to become artists, show strength and perseverance of character. They are not easily discouraged by the Confucian morals that oblige them to stay two steps behind their husbands or persuade them

opposite page: Le Thi Kim Bach at her house in Hanoi, 1995.

below: **LE THI KIM BACH, Young Virgin, 1993,** watercolour on silk, 90 x 70 cm.

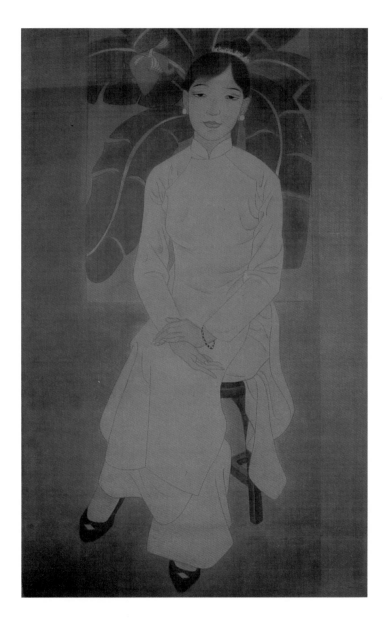

to follow the rules of 'female' art. Kim Bach and Do Thi Ninh have succeeded in gaining a reputation for themselves in official art circles. If the Artists' Union had not helped to foster a balance between men and women artists, these women may have had more difficulty in gaining recognition. Like Mong Bich, in 1966, Do Thi Ninh enlisted in the army and joined the Viet Minh troups on their southern trail. She was only eighteen at the time. Besides participating in daily chores, she spent much of her time sketching soldiers and the surrounding landscape. She remembers this time as being joyful and productive. Her work as an artist was taken seriously. Rather than sacrifice one part of her life for another, she was able to combine her art with other aspects of her life and never felt criticised for it. She also never felt as though she had to distinguish herself from her male peers. She does not like to refer to herself as a 'woman' artist. 'I am just an artist, that's all.'[9] Her work also reflects this. Most of her paintings are in oil on canvas. Sometimes they are very large paintings. Their subjects are varied, but often they represent soldiers, sailors, or workers. She once declared 'I like painting soldiers'.[10] More recently she has tackled the time-consuming and labour intensive medium of lacquer which requires rubbing layers of resin into a wood surface with a stone.

In spite of the sacrifices they had to make towards their personal lives, the profession of painting presented relatively few obstacles for Mong Bich, Kim Bach and Do Thi Ninh when compared with women artists under colonialism and today who did not or do not have the support of the State-funded Artists' Union. Since the government instituted market reforms in 1986 under a policy called *Doi Moi*, meaning 'new change', otherwise known as 'Renovation', artists have had to survive on their own. For most artists this has given them an enormous advantage. They can sell their works in galleries or straight out of their studios. Whereas previously artists had to be sponsored by the Artists' Union in order to hold an exhibition, today artists are free to display their works providing they pay an exhibition space rental fee or are offered an exhibition in a privately owned gallery. The shift to a market economy under Doi Moi has boosted the income of artists ten to twenty fold. Prices for paintings can reach thousands of dollars for well-known artists' work and at least in the hundreds for even the less well known. In a country where the median income for a worker ranges from two hundred to five hundred dollars a year, artists earn substantially more money than the average citizen. Unfortunately for women, the improved economic situation for artists has not extended to them. Without government support, women are left to break into the art market on their own, which often leads to competition with men, who do not let them share the limelight.

Male artists' unwillingness to share their professional environment with women did not just occur after Doi Moi. Prior to that, during the 1950s, 60s and 70s, while women enjoyed privilege under the Union banner, men retreated into back alley cafes huddled over coffee, beer and cigarettes to discuss their art. Until recently, it was common for Hanoi intellectuals to be found discussing literature, art and philosophy while gathered in coffee houses sometimes until late in the evening. These meetings were reserved for men. Women were confined to their homes, taking care of children and domestic chores. Only rarely did they participate in these evenings which often involved drinking and long sittings. Since galleries and other commercial outlets for exhibiting and selling art did not exist until as recently as 1990, cafes were sometimes the only exposure artists had to one another, especially among those who were not affiliated with the artists' unions.

The difficulties in gaining recognition as artists outside the official boundaries of the centralised State system were even more so for women. When the tide turned in 1990 and the art market opened up, it was those 'unofficial' artists who gained a reputation among foreign collectors. Nobody wanted the Union artists and the women who had worked hard to be accepted by the State organisms were rejected by the booming art market of the 1990s. Only one female artist has managed to gain attention, partly because she has chosen to make a statement about the situation. Dinh Y Nhi, born in 1967, like Ninh, refuses to be labelled a 'woman artist'. She also refuses to paint in a conventional way. She doesn't paint on silk, nor does she paint with watercolours, or even colours for that matter. Her paintings are black

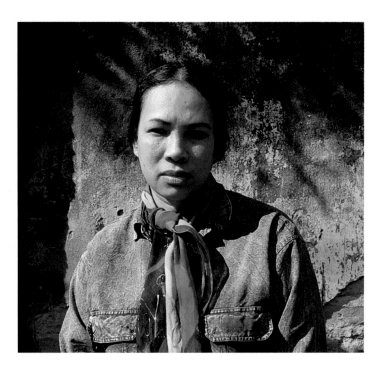

opposite page: Do Thi Ninh at her house in Hanoi, 1995.

below: **DO THI NINH, Thay Pagoda, 1995,** lacquer on wood panel, 60 x 80 cm.

DINH Y NHI, Women, 1995, gouache on paper, 109 x 75 cm.

and white gouaches on paper. They display none of the elements that would be considered 'feminine' by her peers. Her figures are rendered as stick figures with rudimentary lines and shapes. She gives them no space to breathe or move around in, they are pasted on the surface of the picture like paper cut-outs. By deliberately omitting any standard references to 'beauty', classical aesthetics, balanced composition, or colour harmony, she is stating that she wants no part of the art world that the Vietnamese male artists have created.

'I don't paint with colours, because I don't want people to look at my paintings and automatically associate a feeling or a mood or a symbol with them', she says.[11] In Vietnam colours have meaning. For instance, red is a symbol for love, blue means hope, yellow is associated with Buddhism, purple means loyalty, and so forth. Not that every viewer who gazes at a painting attaches these symbols to it, but they are too powerful for Nhi to ignore. She prefers to have a neutral gaze on her paintings. Perhaps colours are gendered for her and painting in black and white and various shades of grey gives her the freedom to be genderless, to be just herself and not a woman painter or a male painter. She says the same thing of her figures. 'I don't like the standards of beauty attached to female figures. In Vietnam everybody tells you that a beautiful person has this shaped mouth or that shaped nose. My figures don't apply to that standard. They are just plain and simple.'[12]

In negating the marks of womanhood or even personhood, she is rejecting her own culture's custom of labelling a person's character by their physiognomy. And in doing this she is denying the features that identify her or her figures as a woman. This is analogous to a type of anorexia, where a woman turns herself into a small girl by depriving herself of food in order not to be recognised as a woman. Nhi seems to be saying that the only way that a woman artist can be free to express herself is by painting ghosts, or figures that are deprived of colour and form. In doing so, she is also saying that women artists can only exist if they are invisible.

None of the four women painters mentioned above have received much critical attention from art historians or art critics abroad. Of the four, only Nhi has gained some commercial success with her works, but her male peers in the artistic circles of Hanoi rarely acknowledge her presence. In contrast to the four, there is one Vietnamese woman painter who has managed to receive both critical acclaim and commercial success, mostly abroad. Van Duong Thanh, born in 1951, married a Swede and went to Sweden in 1989. There she exhibited in several cities and has since exhibited in Bangkok and Singapore. Numerous articles have been written about her in Swedish journals as representative of the 'depth' of the Vietnamese soul. Her paintings are usually highly impressionistic and very colourful renditions of pagodas, flowers and village streets. Her work could not be more different from Nhi's.

Her paintings sell to people who want a 'pretty' picture of Vietnam, rather than to ponder on the social, historical or political situation. One article even describes her beauty as if it had relevance to her work. A Swedish writer wrote: 'With her paintings and her beautiful face, Mrs Thanh has captivated us Scandinavians.'[13]

Thanh's success proves that women painters have to follow the rule that beauty equals femininity and to be a woman painter means to paint what is considered beautiful or womanly by the establishment. In the days when women were given equal rights and attention to personal beauty was considered frivolous, women artists such as Mong Bich, Kim Bach and Do Thi Ninh were given equal opportunity to express themselves in painting, albeit with restrictions. They, like their male peers, were restricted in subject matter: workers, soldiers and peasants were the themes they were commissioned to paint. When restrictions on painters were lifted in 1990, all three of them continued to paint the people around them, because that is all they knew how to paint. For twenty-eight-year-old Nhi, things were different. She was allowed to paint any subject, in any style she wished. She was only restricted by the standards that were set on the roles of women in society and women in painting. Van Duong Thanh freed herself of those restrictions, but limited her creative potential by following a more commercial route, painting for the foreign market.

The position of women painters in Vietnam is far from decided considering the changes that are still taking place in other sectors of society. Whether or not the ideas of equality established under communism will survive the development of increasingly conservative Confucian ethics and the rise of the free market, no one can tell. What we *do* know, is that painting has yet to be used as a medium of expression for the women's rights movement in Vietnam.

1 Nguyen Quang Phong, *Painters of the Fine Arts College of Indochina*, Fine Arts Publishing House, Hanoi, 1993.
2 Conversation with Dinh Trong Khang, Hanoi University of Fine Arts, December, 1994.
3 See for example Duong Thu Huong, *Novel Without a Name*, William Morrow, New York, 1995; Nguyen Thi Dinh, *No Other Road to Take*, Cornell University Southeast Asia Program, Ithaca, 1976; or Arlene Eisen, *Women and Revolution in Viet Nam*, Zed books, London, 1984.
4 Conversation with Nguyen Thi Mong Bich, 1993.
5 Personal communication with Tran Luong, December 1995.
6 Tran Luong, December 1995.
7 Conversation with Kim Bach, 1993.
8 Conversation with Do Thi Ninh, 1993.
9 Personal communication with Do Thi Ninh, 1994.
10 Do Thi Ninh, 1994.
11 Conversation with Dinh Y Nhi, 1995.
12 Conversation with Dinh Y Nhi, 1995.
13 Taghe Malandr, quoted in an article about Van Duong Thanh in *Woman of Vietnam*, Issue No. 3, 1992 (published by the Vietnam Women's Union, p. 6).

Nora Taylor is a PhD candidate, Cornell University, USA.

india songs

gayatri sinha

The subject of Indian women artists assumes a fuller outline when seen in the historical context of woman as subject and, more occasionally, as artist. Playwright Kalidas's women characters of the fifth century speak unselfconsciously of their skills in painting in the play Abhigyan Shakuntalam; a miniature in the Bharat Kala Bhavan collection at Varanasi of the Mughal period shows a woman artist painting a group of women. But the woman as artist who looked upon art as a means of professional livelihood emerged on the Indian horizon with Amrita Sher-Gil only in the 1930s. Within the next few decades the four major art colleges in Bombay, Calcutta, Madras and, later, the addition of Delhi had attracted as students some of today's leading women contemporary artists. Women sculptors, graphic artists and painters are now visible and significant.

The significance of this lay in some tentative formulations which, by the late 1980s, had become a full-blown statement. Like artists across the board, women artists of the 1950s were grappling with questions of Indian identity in art and with visible signs and symbols of this identity, an uneasy balance between the vast bedrock of tradition and every glancing wind of modernity and change.

The inheritance of the Indian woman artist of the twentieth century was a complex pastiche of images, narratives and the contemporary role models of the twentieth century. To take the 'classical'

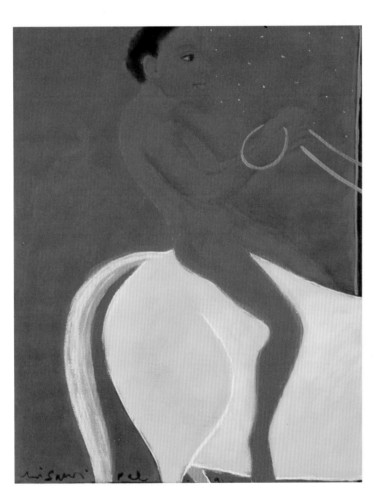

GOGI SAROJ PAL, Swayambaram, 1990, gouache on paper, 60 x 90 cm.

opposite page: GOGI SAROJ PAL, Kinneri, 1989 gouache on paper, 30 x 18 cm.

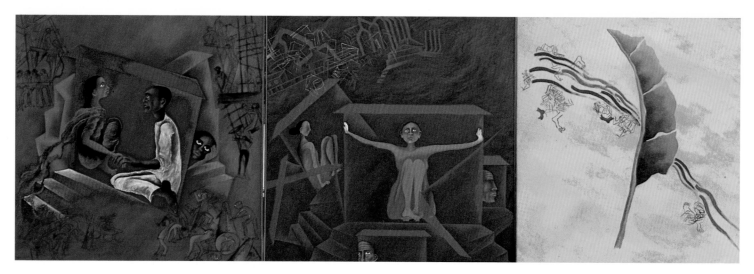

ARPANA CAUR, **Resilient Green, 1991**, (triptych) oil on canvas, 5.5 x 1.8 m, Glenbarra Museum, Japan.

image first, between the sixteenth to the mid-nineteenth centuries the woman as the *nayika* or heroine had become the conventional image in formal, courtly art. The chief literary exponents, like Bhanudatta in his fourteenth-century treatise *Rasamanjari*, or Keshavadas in his *Rasikapriya* portrayed women in a highly codified manner, and categorised beauty and erotic skills into distinct 'types'. Within these conventions the sati of Sita, Parvati's long vows of abstinence to attain the Lord Shiva as her husband, the long and painful separation endured by Radha while Krishna dallied with the Gopis or milkmaids, were privileged as the heroic.

Miniature artists in the Rajasthani states, the Punjab hill states, in parts of the Deccan and the kingdom of Avadh subscribed closely to this model. The ideal *nayika* was Krishna's beloved Radha, the eternal image of blossoming youth and beauty, and passionate, frequently unrequited love. Such love imagery, with all its attendant symbols in nature, music and colour, was faithfully reproduced by artists. The outcome was an art of extreme refinement and feminine sensibility. But it was also one of objective idealisation, of straightjacketing the individual woman within a rigid notion of beauty, and of eliminating all that which did not adhere to that concept.

Certain characteristics of the *nayika* were well established: that she was always portrayed in a manner that showed off her physical charms, that she spent the greater part of her time waiting for her beloved, and that outside this elaborate love narrative she had little or no other identity. Of the eight prominent kinds of *nayikas* described by Keshavadas – arguably the poet with the most influence on miniature art – seven kinds are described in attitudes of waiting for the beloved, who may be trysting elsewhere. The *nayika*, through the perennial attitudes and postures of waiting, privileges the concept of separation, betrayal and unrequited love. Furthermore, through other pointers in the paintings she reinforces class attitudes towards the beautiful, bejewelled young heroine and her undistinguished ladies-in-waiting. In scores of paintings the lady is seen with her female attendants, who attend to her toilet, regale her with music and confidences and then fade away as her lover approaches.

The woman as object gained in definition with a favourite theme of the eighteenth and nineteenth centuries – the courtesan. Woman as singer, dancer, entertainer and courtesan had become a distinct artistic subject under the British presence. A single male patron surrounded by a bevy of women attendants, a British nabob being entertained by nautch girls, and the bejewelled courtesan became common subjects as the hold of religion receded.

Interestingly, as the nationalist movement began to gain momentum and social reform for women was a determinant of the political agenda, artists tried to reform this image in art. Raja Ravi Varma (1848–1906), who inherited the nautch girl tradition (he writes in his diaries of being entertained by them), consciously sought to 'restore' the image of pristine womanhood. It is a moot point that Ravi Varma virtually ignored the issues addressed by social reformers on widow remarriage, child marriages, sati, women's education and legal rights. Instead he sought to recreate a picture of the Hindu halcyon age and clothed it in Victorian concepts of sensuality and beauty. Themes in his paintings derived from the age of the Puranas and the epics privileged those very notions of dependency and unquestioning sacrifice that the reform movements were to address. His epic women like Sita, Draupadi and Shakuntala invite the male gaze while combining attitudes of Indian piety and purity.

Further, his enormously popular series on Indian beauties such as *Veena Player* or *Malabar Beauty* set new standards of idealised womanhood. These women, like the *nayikas* before them of the miniature tradition, bore all the emblems of refinement and class superiority. Their fair skins and coiffures served as a background for gleaming jewellery, their homes established their place in a wealthy patrimony and their nominal use of musical instruments stressed the genteel pursuits of high born women. In his painting *Galaxy of Musicians,* 1899, eleven women musicians dressed in the fashion of different regions are presented. They are an image of integrated dignity and grace that seeks to re-establish normative values after the devalued image of the woman musician in the miniature tradition. Ravi Varma's own royal antecedents, his inherent knowledge of the finer modes of dress, gesture and class became the presumed bedrock of values on which he built this image. An important woman artist of this period was Ravi Varma's sister Mangalabai Thampuratty who painted with considerable freedom; Ravi Varma also had some women students, like the Parsi lady Miss Karagati.

Ravi Varma and his imitators not only had a clinching influence on theatre and calendar art, but also on successive artists. Epic and Pauranic themes became the mainstay of Bengal school adherents, and artists in Bombay, Delhi and other art centres. Stylistic differences with Ravi Varma notwithstanding, several leading painters of the first five decades of this century such as Abanindranath Tagore, his leading disciple Nandalal Bose, M.A.R. Chughtai, Jamini Roy and S.L. Haldankar virtually reinforced the values of affected piety and sensuality that were Ravi Varma's. For instance, Nandalal Bose's *Ritu Samhar* in the National Gallery of Modern Art Collection is based on the title of Kalidas's poem and pictures a bare-breasted bejewelled woman in the Ajanta painting mode. As late as the 1950s Nandalal Bose made a painting on sati, thereby partially nullifying the involvement he also had with Congress politics and nationalist aspirations.

Against this somewhat charged scenario Amrita Sher-Gil (1913–41) set a conspicuously different agenda for the woman as subject and the woman as artist. Her several portraits and academic studies on nude women inject the first deliberately unselfconscious element in the portrayal of women. The viewer's gaze need not be avid or pious. While Sunaini Devi, a sister of Abanindranath Tagore, reverted to the more fundamental themes of the known icon like the lotus-borne goddess Lakshmi or round-faced milkmaids, Sher-Gil's figures have a romantic self-preoccupation. As in her famous *Woman on Charpoy*, the body of the woman reclining on the bed is held unselfconsciously; this central woman's internal reverie sets the mood of the painting.

Sher-Gil's influence on later generations of Indian artists is due for assessment. Nevertheless, for successive women painters she repre-

RAGAPUTRA VARADHAN, Miniature painting, provenance and school Kangra (The theme of separation), 1790, National Museum, New Delhi.

JAYASHREE CHAKRAVARTY, **Within the Nature, 1992,** oil on canvas, 100.3 x 59.7 cm, courtesy the artist.

sents probably a ninety-degree turn of latent possibilities. In her art she demystifies and desanctifies woman, and introduces a degree of introspection.

Four decades later, in the work of Gogi Saroj Pal this quality of introspection appeared as a full blown critique of Indian womanhood. An artist who questioned social repression in the mid-1970s in grey, dark etchings, she gradually began using images from Persian and Indian miniatures, with a complete reversal of intent. Unlike the *nayika* of miniature art, Gogi's *nayika* is a slightly unthinking, quiescent and willing accomplice in her own domination. In a freewheeling arc that stretches from eclectically chosen Hindu and Islamic myths, she plays upon the image of the inherent bestiality of gender domination. The woman beast, like the fabled minotaur of Greek myth, has potential energy, but in the evolutionary scale stands lower than man, the *Homo sapiens*. Gogi's continual reference points are Kamdhenu, the wish fulfilling cow of Hindu belief, *buraq*, the mythical creature of Islamic legend, and *kinnari*, the mythic bird. Kamdhenu, who mutates into a woman cow in her series 'Swayambara', represents the woman's perennial capacity to give, with no expectation of return.

The associations with Indian mythology are intrinsic to Gogi's pictorial language. But she subverts the image to cock a snook at the accepted images of Indian womanhood. For instance, all significant male and female Indian deities ride an animal mount that has little identity outside the service that it renders. Like the divine mount, but in subtle mockery of the synthesis of the goddess and mount image, her woman is both potential *shakti,* or divine power, and beast rolled into one – this is her contradiction, and her limitation. Gogi demolishes the *shakti* concept of woman power, the lion-riding goddesses Durga or Amba, by projecting the passive woman-cow or gentle woman-bird. More than a decade ago in an explicit image of sexual domination, the woman-beast carried a man on her back. Gradually, her face became more obviously painted, her smile more provocative and inviting, her bodily curves fuller. The apparent statement is fluid, feminine, even sly, but its true worth would lie in plotting a paradigm of the feminist movement in India and Gogi's art. For Gogi has never reacted to individual news events, but the status of women as a whole.

On the surface, the affinities between Gogi Saroj Pal and Arpana Caur reside in their stylistic indebtedness to Pahari miniature painting and the use of the woman protagonist. But while Gogi's gaze is cool and acerbic, Arpana's identification with her subject is total. Caur stops short of being an artist activist but there is little among Indian feminist concerns that has escaped her. And despite the overt symbolic and philosophic strain in her work, her position is never ambivalent.

A self-taught artist, Caur has in two decades moved through several distinctly articulated 'phases'. In 1974 she exhibited 'Women in

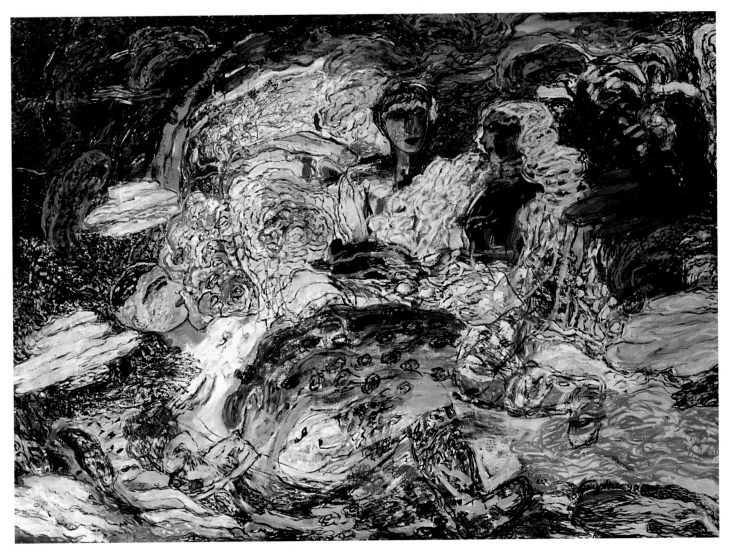

JAYASHREE CHAKRAVARTY, **Spreading Landscape, 1992,** oil on canvas, 176.5 x 130.8 cm.

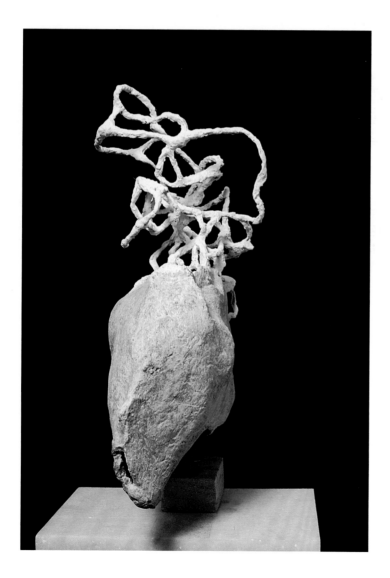

LATIKA KATT, **Growth Head, 1991**, papier mâché, courtesy the artist.

Interiors'. In these paintings, rising urban walls tilt precipitously to depict urban claustrophobia – an ironic parody of the beautiful high walls that rise around women in Indian miniatures, and literally define their physical space. Almost immediately Caur developed her feminine type – large, staring eyes, bony frame clad in the Punjabi *salwar kameez* who, despite her looming presence, appears vulnerable, victimised. The woman mutates fluently from a young girl being initiated into the mysteries of life into the old shaven-headed widows of Brindavan who wait for a Lord Krishna who never comes, to the woman who sits and endlessly embroiders an amorphous garment of life. Caur's symbolic references draw from Punjabi sufi poetry and medieval bhakti litera-ture, which she merges with Indian contemporary political and gender reality. A recent series indicates that she is gradually moving from images of social conflict to inner resolution. The triptych *Resilient Green* progresses from images of oppression to release, and finally the zone of the unbonded spirit.

By the time we reach the work of Mona Rai, gender distinctions and the oppression of patriarchy is no longer a priority subject. Rai, who is forty-six years old, has been committed to abstraction for decades. The singular quality of her work is its highly textured surfaces. Occasionally turgid and staring, like the city's walls, or minutely worked like a piece of embroidery, Rai's work is emotional yet depersonalised. Like Arpita Singh, she reacts in her work to the invasion of privacy, to big city vio-lence and personal grief. 'People don't interest me,' says Rai. 'I am fasci-nated by the roads and the walls of Delhi, by the galaxies and nature.' Typically, she has long fallow periods, and then paints at a steady speed, using thick application of acrylic with cathartic intent. The paintings themselves contain both this harmony and an explosive energy. Areas of tension created through mottled streaked paint are relieved by ribbon-like stretches of dainty polka dots, and look like an aerial view of the city itself, with its divisions, inner tensions and long streets. The violence of the city, its frequently rent fabric, is seen in her collage *Red and Silver*. Here, her use of torn canvas and rope indicates a move towards further enhancing the surface texture of her work; in recent watercolours Rai has used turmeric, clarified butter, red chilli powder and even rain water in her experiments with materials and textures.

Like Mona Rai, thirty-seven-year-old Jayashree Chakravarty uses paint density, volume and colour expressionistically. But unlike the basic grid in Rai's schemata, Jayashree uses colour in vertigo-inducing whorls, like an oceanic wave that churns and tosses human debris around in its intensity. Like most Baroda school artists, Jayashree's ref-erence point is the figure. After Baroda she studied at Shantiniketan where K.G. Subramanyan taught her to use the brush instead of the spatula for the same textural effect. Initially, she began painting in the miniature format and the white sun-bleached Kota landscape that she

Latika Katt with her installation Soft Sati Arthi – Decaying City, 1994, bamboo, ceramic, papier mâché.

MONA RAI, **Red and Silver, 1994,** collage, acrylic and aluminium, 93 x 115 cm.

saw on the train travelling to and from Baroda appeared in this work. By the mid-1980s, however, she had fully developed her expression-istic brushstrokes which dip, rise or spiral in space. The figures, hair afloat and buoyant as in water, enact their own deeply personal tableaux. Alone or in small groups they appear to communicate word-lessly in the charged, dramatic landscape. Recently married to a French flautist, Jayashree's shift to Aix marks a shift in landscape and images. Jayashree's work has reflected this continental shift — men in hats and gumboots, like Gallic fishermen, now appear.

Unlike the volatile surface quality of her paintings, Jayashree's char-acters are oddly gentle. They float or recline like swimmers in an uncertain terrain, intent only on their own inner rather dreamy modes of communication. In contrast is the work and personality of Latika Katt, one of the few Indian women sculptors who seems to be buoyed by her own self-propelled enthusiasm. Katt uses sculpture like a sounding board. It is as if she chooses the hardest or the most fragile materials and then tests her will against them, through an interplay of subversion and contraries. Ceramic is moulded to rise to gravity-defying heights, glaze is used not for its patina but like thick impasto paint, and marble is carved out to look like the meal of a multitude of white ants. The fragility of the hardest stone, the tensility of the soft and the organic potential of inert matter become her concerns.

Katt, who graduated from the Benaras Hindu University and the MS University Baroda, also trained at the Slade School in London. At Baroda she learnt some of her most critical lessons when her father's sudden death pushed her between an emotional and a financial pincer. Materials were unaffordable, but she wanted to live independently of her family, and her wealthy roommate. Walking around Baroda's Kamati

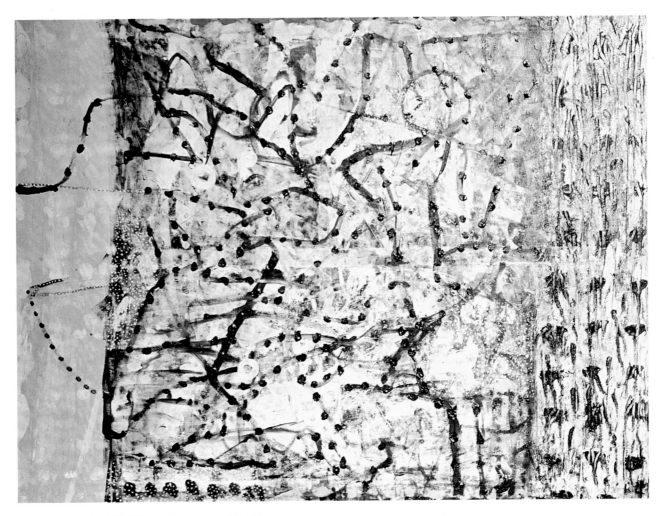

MONA RAI, **Painting A-17, 1992**, acrylic on canvas, 121 x 158 cm.

Bagh one day she saw how the poor filled the breaks in the fence with cow dung, and knew she had found her material. Each morning thereafter at 6 a.m., she would collect her 'material' in a pail and produced a series of cow dung sculptures. And the rich roommate's head became a prototype that Latika has reworked endlessly since.

Deeply interested as she is in simplifying natural forms, Latika is best known for her heads and busts. Foremost among these is a twenty-feet high bronze sculpture of Pandit Jawaharlal Nehru. She also has heads of the slain theatre activist Safdar Hashmi, the writer–scholars Mulk Raj Anand and Ratan Parimoo and the artists Jeram Patel, Ram Kinkar and Somnath Hore.

Latika's indomitable feminist streak, which she traces to being a girl in the all-boys institution, the Doon School, decided her response to Roop Kanwar's sati at Deorala in 1989. That the girl was immolated against her will provoked a storm of protest; Latika responded by creating a series of sculptures around sati. Again, the contraries and the apposite images set to work. The 'havana', or ritual purifying fire of the Hindus, is created here as the sati sacrificial site. Steps leading to it were directly inspired by the Colosseum in Rome, and the association of spectator delight and arbitrary death. Similarly, the scene at Manikarna ghat in Benaras, where ritual fires consume the dead bodies, has been recreated in her work. But the mood is one of passion, rather than stoicism, of quest and innovation, in the spirit of the best contemporary Indian art.

Gayatri Sinha is an arts journalist who lives in New Delhi. She is the author of the forthcoming book *The Woman in Indian Art* (UBS, India) and presently working as Guest Editor for the Marg publication *Indian Women Artists of the Twentieth Century*.

materialising dream

the paintings of arpita singh

nilima sheikh

Arpita was talking about the mysterious business of painting a painting. She described how she keeps painting this or that, ladening the surface, adding images. 'I keep painting, but not fully knowing what I am really painting, then suddenly just for a flash it becomes clear what it is all about ... That must be so for all artists, isn't it?' she suggests. 'Yes, yes', I nod in agreement, pleased with her observation, thinking how true it is, a good description of that propitious moment. But then in Arpita's case there is a difference. The game of artifice that painting is all about becomes doubly so with her, tricking and beguiling the viewer into a seemingly no-win game of illusion and recognition. The deceit of mirage is entrenched in the process of the coming to be of her paintings, into the components of their structure. Look for secret trapdoors and open-sesame codes if you like, but if you begin to think that the meaning is more important than the game, or that the 'ultimate' answer is round the next bend and yours for the finding, you may well trip up. An entry may mean a maze or a cul-de-sac. Many beginnings and no end.

If one were to look back upon Arpita's paintings of the last ten or twelve years one would find the strategy for subversion worked carefully into almost all their manifest attributes. It follows fastidiously posited 'because of/'in spite of' codes. There is in her paintings the substance of wakeful dream

ARPITA SINGH, **My Mother, 1993,** oil on canvas, 137 x 183 cm, private collection.

opposite page: **ARPITA SINGH, Seated Woman with a Shawl, 1993,** watercolour and acrylic on paper, 40.6 x 29 cm, private collection.

ARPITA SINGH, Blue Water Shirt, 1994, watercolour and acrylic on paper, 35.5 x 50.8 cm, private collection.

materialising image and mirage, body and fabric. It is made not only by teasing paint and pigment – layered on, impacted and pushed around – but equally by removing, scraping, mottling and limning, as in her watercolours. The making of beauty obsesses Arpita. For her the pleasure and ploy of ornamentation is both celebration and disguise. Along with modernist techniques of painting she foregrounds other devices to celebrate the surface: the use of decorative motifs, patterning, and what I would like to call illuminating, inexorably bringing to life – tending – a surface she fears might dull. Or, if it is not offered life through touch or sign, might even die. Yet more often than not the motifs offered are funerary, about mourning the dead and celebrating dying. About living in spite of dying. About enacting death. In Arpita's paintings is that different from enacting living?

Over the years Arpita has packed into her bundle of skill and expertise all kinds of things. For all the radical changes and disjunctures in her career, she does not really discard things – a syntax or a particular painting device – for having grown out of them; you never know when they may come in handy again. Yet I would say it is important for her to invent, every day. And still it would not be a contradiction to say that for Arpita our tapestry weaver, repetition is the warp of invention. She uses it to lay the ground-field of her world. The rhythms of repetition form structure and continuity within her paintings and between them. She now puts no premium on originality, realising in her wisdom that it would be an irrelevant straitjacket, redundant when she needs all her resources to garner new means to cope with the world at her doorstep: to invent strategies of survival – terms of acceptance and of resistance in the grim, funny and beautiful business of day-to-day living.

So for her magic bundle she gathers new visual stimuli, raw material for new textures, new bodies, new metaphors as she comes across them. From that she selects, mixes and matches – making and unmaking the iconography of her paintings. Posies, patterns, baskets of flowers, birds, ducks, the girl-child's bric-a-brac and what was not hers, guns and aeroplanes; the paraphernalia accrued from the pleasures and pains of tending home, enjoying neighbours' confidences, their clothes and faces, mourning with other women; from thinking about books read recently or old stories remembered; from wrestling manuals and modern dance configurations; from the layer of textures on the surface of the lily ponds in the capital's cultural complexes or from the activities of men groping, grappling, crouching, sleeping, dying down there, just below – the motifs she has chosen to inscribe as stereotypes change meaning in spite of/because of obsessive repetition. Marks which in the early 1980s signalled disjunction, today may signal the stigmata of the vulnerable, a noughts and crosses game of fascist marksmanship. War-planes and pineapple share accommodation on the elaborate breakfast-table decor turning chillingly into the reality of

ARPITA SINGH, Family Lily Pool, 1994, watercolour and acrylic on paper, 50.8 x 35.5 cm, private collection.

ARPITA SINGH, **People Around the Table, 1993,** oil on canvas, 122 x 122 cm, private collection.

tabletop war spectacle. A naked woman turns away to face us, dully, the vulnerable body is the body of resistance, 'holding out'.[1]

When, in 1972, Arpita was persuaded by Roshan Alkazi to show her paintings after a longish period of professional hibernation and a maternity leave, the community of artists were captivated. But perhaps they were also a little intrigued as to why this independent woman of incisive intelligence known for her frank repartee – quite a firebrand, I am told – had decided to play Alice in Wonderland. The sources of her paintings were modernist and not unknown: Klee first of all (fairy godfather to much of Indian art in the 1960s and 1970s), surreal surprises, recourse to the naive – Chagall, even Rousseau perhaps, but whimsy was the means to be personal, and different. Neither the decision nor the choice of masquerade was ungendered: how clear that seems now. The protagonist/author was a young girl armed with a story book. Did Arpita know when she pulled the facade of quaint, tongue-in-cheek whimsy over her new vulnerabilities that the language of transgression she was seeking would equip her to take on the world, living and dying as it encroached stubborn and relentless into her life. Men in suits and a post-Pinter consciousness had pushed their way into Arpita's women and children zone and disrupted the rhythm of women's bodies attaining iconic grace by the simple if seemingly ridiculous belief in the sanctity of their vocation – the rituals of daily living. After the Gulf War, militiamen formed phalanxes, tumbled around and pointed guns, their manoeuvres learnt from picture books tending to get obstructed by reclining multi-armed beauties doing proxy for city monuments. In Arpita's maze-cities of the last four years a great deal of men in their uniforms of conformity rush around sometimes as lawyers in a comic book Camus, sometimes in mufti, as plainclothes men or as goons. But now they sometimes take off their costume or put on others: the pensive gold-ochre man wearing a Baconesque nakedness watches two pink-brown men grappling in slow motion combat, and the men regarding the death on the street wear little frocks. I had marvelled while I watched Pina Bausch's dance-theatre production 'Carnations', marvelled also at how two women working in different media in different parts of the world said things in so many similar ways: the stage-surface of flowers, beautiful, sumptuous, artificial; men in suits and dress jackets, militiamen, pointing guns across the canvas; the absurd 'irrelevant' games, men in multi-limbed configurations tumbling in mock combat or using a table as weapon for nightmarish intimidation; the endless repetition of absurd synchronised movements/gestures/ motifs, the multiple, sometimes simultaneous, registers through the layering of structure and meaning, the asides, the interface of the margin, the transgressions – achieved with beauty and humour.

Yes, Arpita paints beautifully. She has spent quite a lot of time learning how. After practising the calligraphy of modernism in accomplished

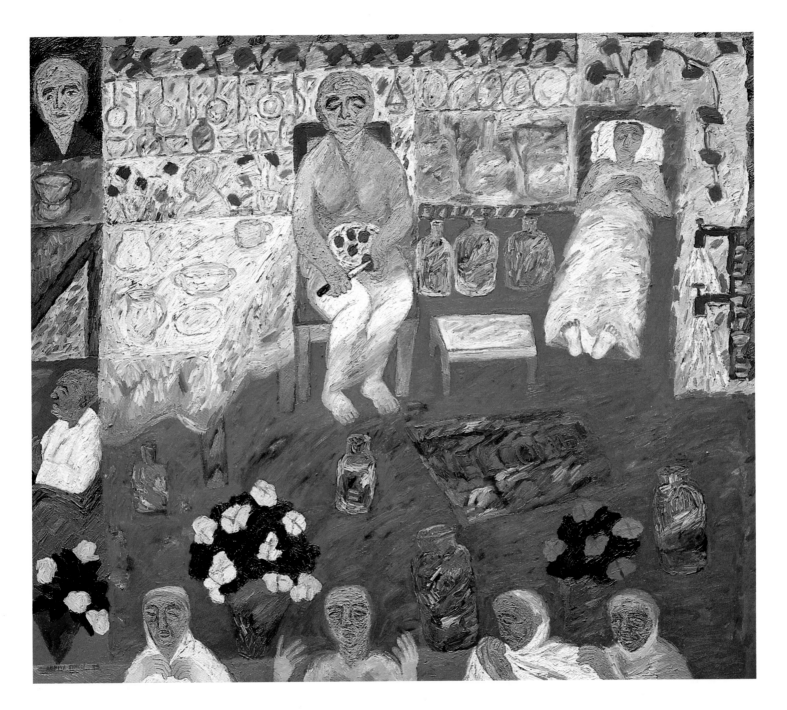

black and white abstraction during the second part of the 1970s she switched to painting abstractions in subtly nuanced and gleaming colour, dexterous in handling oils. Yet, even before the flags popped out of the abstract terrain to signal new directions, the care with which each daub and patch was laid on to the entire surface of the canvas was unusual. The pleasure in fabricating the surface of the tapestry made her a little unmindful of the reductive rules of modernist abstraction. After the flags in the early 1980s, cars, aeroplanes, ducks, portrait-busts and toy guns tumbled out, clamouring for recognition of their identity – 'through the looking glass'. This was the beginning of the elaborately coded world of Arpita's painting today and was, as well, the beginning of the multiplying inventiveness in drawing and painting demanded by its overlapping registers. She recycles her modernist expertise for painting in oil and grafts onto it such varied sources as naturalism, picture book illustration and the textile crafts – weaving,

stitching and embroidery. The watercolours are set on a different premise: their scale and medium enlists a more direct connection with the art of illustration. Some of the greatest painting traditions of the world endorse the fertility of this source, Arpita would seem to suggest. And she has painted the life of Nanak to acknowledge her allegiances – to book illumination, to the medieval, to fictionalised narratives and to the making of legend – and in the painting-drawing techniques of her watercolours. The delineation of the body and garment of the female icon, the suffusion of colour and surface by a fastidious limning process, the use of gold and silver grounds to contain the embedded colours in a shimmering surface equilibrium, inscriptions and the different graphic means used to register the asides and the counterpoints bring to mind the devices of European medieval manuscript illumination and icon painting. The pictorially active edge which borders most of Arpita's paintings to signify the process of completion is

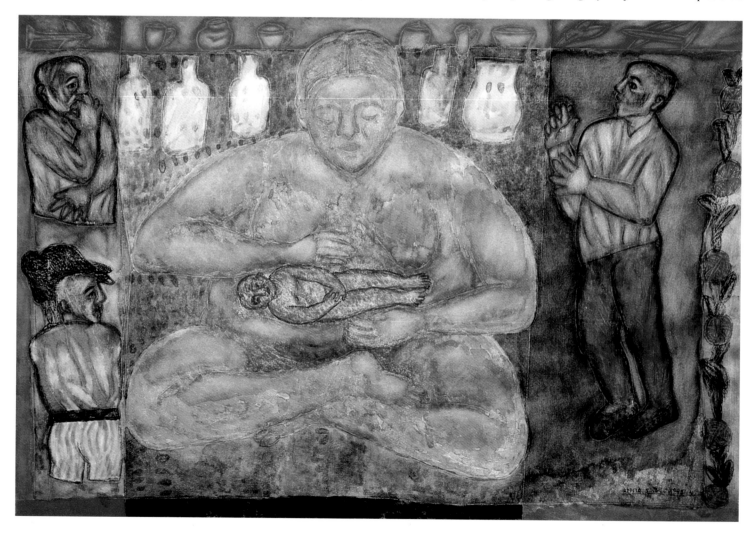

usually in itself incomplete. It often looks like a tantalising vignette of another layer of painting underneath, or the next page of our picture book waiting to be turned …

The artist's mother is out on the streets protected (if it can be called protection) only by her own single-mindedness. A grey road, site for motor-vehicles, dead and dying men, running diagonally across the painting separates her from a marked city, lying askew, peopled by the ubiquitous men in khaki, some people living, dying, grimacing or offering bouquets. The tapestry is woven on a white warp: white shrouds, white garments for the living, white for setting off the beautiful edge of pain, of colour and flesh. There would be martyrs and survivors when a city wages war on itself. You might come across them amongst the absurdities strewn into the city fabric, one tucked away on its edge trying with her arms splayed 'to hold something'.

The woman of Arpita's new watercolours has grown, to fill the paper sometimes. In some paintings she seems to grow larger than the daily-life arena where she had juggled her size and place with other members of the repertory. She is the large mother holding her golden girl-child in the soft warm pink and blue-brown folds of her flesh as she would have done inside her womb-cave, heir to the legend of Yama-uba the mountain woman that Utamaro illustrated. But most of all Arpita's new protagonist brings to mind Jeanette Winterson's Dogwoman in *Sexing the Cherry* – large, caring, frontal, mythic, urban and funny, stepping across history to belong to other times. She may also be pock-marked, diseased and probably mad, an outcast, a red, looming *bairagin* on the outskirts of a medieval town. She has also grown older.

Of late Arpita often paints the ageing woman – as icon, as protagonist, sometimes naked – baring the post-menopausal sexuality of her body. In *Afternoon*, a truly remarkable painting, she shares her space with her mate. They stand, fingers interlocked within the familiar intimacy of home in a stilled moment of the afternoon. The distances of familiarity and routine seethe on the surface, materialising desire and fear, then dissolving body. The conjugal bodies are painted in relentless pale daubs of Indian red and terreverte – colours of the earth – touched with blue-grey shadow that both make and dissolve luminous body mass, the repeated sensory stimulation simulating the pulsations of desire. This is the very private moment, not only of desire but of its vulnerable incompleteness. Then the chilling recognition of violation dawns on us. The goons that have been running amuck over Arpita's paintings stand lined up – ten of them, small, stubborn and silent at the threshold-edge of our space, and one of them points a gun at it.

1 The term 'holding out' is taken from the title of Geeta Kapur's illustrated lecture 'Holding Out: Women Painters at Work' delivered in February 1993 at the Faculty of Fine Arts, Baroda.

Nilima Sheikh is an artist who lives in Vadodara, India.

opposite page: **ARPITA SINGH, A Woman with Girl-Child – 11, 1994,** watercolour on paper, 35.5 x 50.8 cm, private collection.

below: **ARPITA SINGH, Afternoon, 1994,** watercolour and acrylic on paper, 50.8 x 35.5 cm, private collection.